FOUNTAINS ABBEY
THROUGH TIME
Alan Whitworth

AMBERLEY PUBLISHING

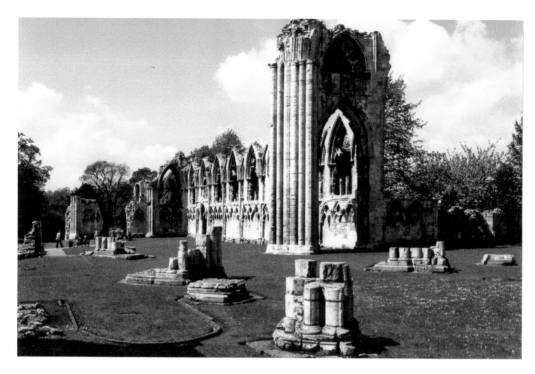

The Ruins of St. Mary's Abbey, York.

This work is dedicated to the staff of Boots the chemist, Whitby and in particular, Joey, whose bright smile and excellent service is a credit to the company.

First published 2011

Amberley Publishing
The Hill, Stroud
Gloucestershire, GL5 4EP

www.amberley-books.com

Copyright © Alan Whitworth, 2011

The right of Alan Whitworth to be identified as the
Author of this work has been asserted in accordance
with the Copyrights, Designs and Patents Act 1988.

ISBN 978 1 4456 0611 8

British Library Cataloguing in Publication Data.
A catalogue record for this book is available from
the British Library.

Typeset in 9.5pt on 12pt Celeste.
Typesetting by Amberley Publishing.
Printed in the UK.

Introduction

In the winter of 1132, following a dispute and riot at St Mary's Abbey in York over religious differences, thirteen monks were exiled. Taken under the protection of Archbishop Thurstan, of York, they established themselves near Ripon on an estate freely offered by a powerful cleric. They had desired loneliness and hard living, and they were taken at their word.

In the valley of the River Skell 'was a place which had never been inhabited, overgrown with thorns, a hollow in the hills between projecting rocks; fitter, to all appearance, to be a lair for wild beasts than a home for men'.

Within three years, the little settlement at Fountains had been admitted to the austere Cistercian Order. Under its rules, the monks lived a rigorous daily life, committed to long periods of silence, a diet barely above subsistence level, and wore a white habit of coarse undyed sheep's wool (underwear was forbidden), which earned them the title 'White Monks'.

The foundation in 1098 of the Cistercian Order, who sought the simplicity and austerity of Benedictine monasticism, was a rebellion against the complex rituals and lavish buildings that had taken the place of pure monastic worship by the close of the eleventh century. The first Cistercian abbey was founded at Citeaux, France, from which the new Order took its name. In England, the first Cistercian abbey was founded at Waverley, Surrey, in 1128.

The personal drive of St Bernard of Clairvaux – who had been a monk at Citeaux – and the message he and his abbots preached, gave tremendous impetus to the Cistercian Order and attracted many patrons eager to associate themselves with such piety.

One of the Cistercian's important developments was the introduction of a system of lay brothers. They were usually illiterate and relieved the monks from routine jobs, giving them more opportunity to dedicate their time to God. Many served as masons, tanners, shoemakers and smiths, but their chief role was to look after the Abbey's vast flocks of sheep, which lived on the huge estate stretching westwards from Fountains to the Lake District and northwards to Teesside. Without the lay brothers, Fountains and the Cistercian Order in general could never have attained its great wealth or economic importance.

The consequences of their success, however, were ironic. By the thirteenth century the elaboration in worship and the wealth generated by the monks' hard work and business acumen showed that even the Cistercians had failed to escape the world they had once renounced, and they came to be accused of the very faults of which they had once accused others.

Fountains, by the middle of the thirteenth century, was one of England's richest religious houses thanks to farming, mining lead, working iron, quarrying stone and horse breeding. But the seeds of failure lay in the very success of the system. The lay brothers encouraged the monks to extend their estates beyond what was necessary for monastic self-sufficiency.

In the fourteenth century, economic collapse followed bad harvests and Scottish raids, and the Black Death exacerbated the effects of financial mismanagement. Many of the monastic granges were leased out to tenant farmers, and in the late fifteenth century, dairy farming replaced sheep farming.

Nevertheless, despite its financial problems, Fountains Abbey remained of considerable importance. The abbots sat in Parliament and the abbacy of Marmaduke Huby (1495–1526) marked a period of revival that was to last until monastic life was brought to an abrupt end by King Henry VIII's Dissolution of the Monasteries in 1539.

Often described as 'the greatest and most glorious abbey in Yorkshire, perhaps in all England', this magnificent Grade I listed monument in the ownership of the National Trust is the largest monastic ruin in Britain.

Sat on the banks of the River Skell, the abbey ruins provide the dramatic focal point of the eighteenth-century landscape garden at Studley Royal, one of the few surviving examples of a Georgian 'Green Garden'. Famous for its water features, ornamental temples, follies and magnificent vistas, the garden is bounded at its western edge by a lake and 400 acres of deer park. The whole today, is designated a World Heritage site, and rightly so.

Author's Note

Because of tree growth and landscape changes over time it is often not possible to reproduce the exact view point on many of these postcard scenes, as a consequence there are times when I have had to substitute a view, or merely reproduce an architectural detail in an effort to capture the sense or spirit of said view.

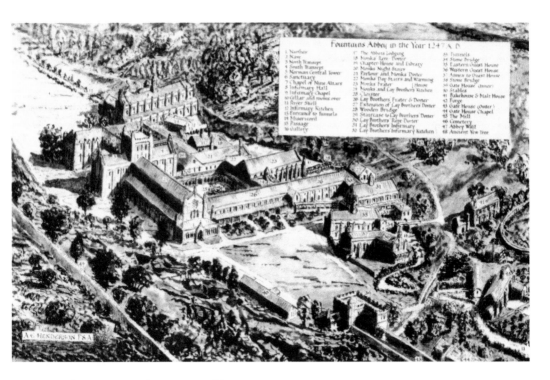

1 Narthex
2 Nave
3 North Transept
4 South Transept
5 Norman Central Tower
6 Sanctuary
7 Chapel of Nine Altars
8 Infirmary Hall
9 Infirmary Chapel
10 Cellar and rooms over
11 River Skell
12 Infirmary Kitchen
13 Entrance to tunnels
14 Misericord
15 Passage
16 Gallery

17 The Abbots Lodging
18 Monks Rere Dorter
19 Chapter House and Library
20 Monks Night Stairs
21 Parlour and Monks Dorter
22 Monks Day Stairs and Warming House
23 Monks Frater
24 Monks and Lay Brothers Kitchen
25 Cloister
26 Lay Brothers Frater & Dorter
27 Extension of Lay Brothers Dorter
28 Wooden Bridge
29 Staircase to Lay Brothers Dorter
30 Lay Brothers Rere Dorter
31 Lay Brothers Infirmary
32 Lay Brothers Infirmary Kitchen

33 Tunnels
34 Stone Bridge
35 Eastern Guest House
36 Western Guest House
37 Annex to Guest House
38 Stone Bridge
39 Gate House (Inner)
40 Stables
41 Bakehouse & Malt House
42 Forge
43 Gate House (Outer)
44 Gate House Chapel
45 The Mill
46 Cemetery
47 Abbey Wall
48 Ancient Yew Tree

A Bird's-Eye View of Fountains Abbey

St Mary at the Waters, better known as Fountains Abbey. For many people, this Cistercian abbey is *par excellence*: the largest and most complete of any of England's abbeys and monasteries. The postcard above shows how the great abbey might have looked when complete. Below, the site is not easy to appreciate until you see an aerial photograph, then you realise the extent of its boundaries.

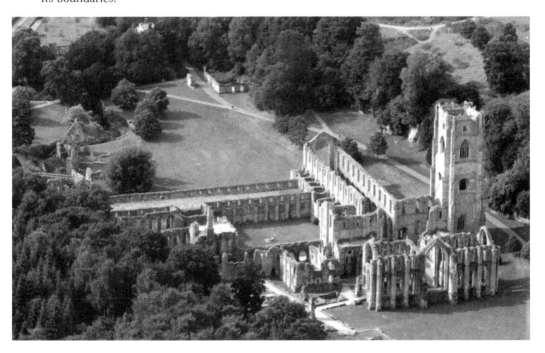

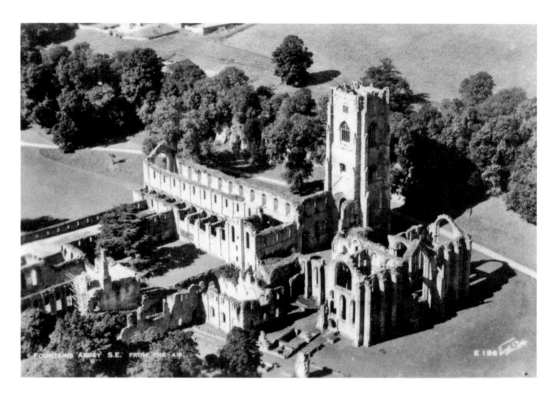

More Aerial Views of Fountains Abbey

It was here, on derelict land beside the River Skell, that the thirteen monks first settled and almost expired in the harshness of their first winter. They continued to camp here, living hand to mouth, until 1135 when they practically called it a day. In that year, Hugh, a Dean of York, who resigned his position and joined the community, brought with him a significant financial endowment.

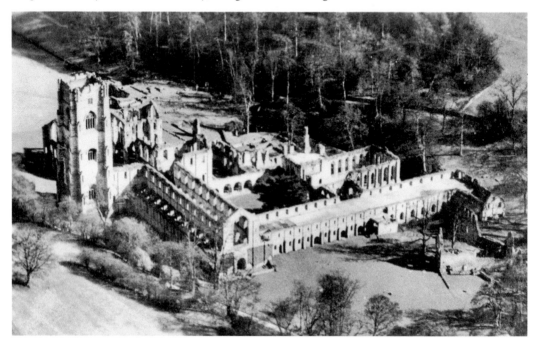

An Early Stereoscopic View of Fountains Abbey

In their fragile first years, the monks of Fountains, not then attached to any monastic order, made a successful application to St Bernard, Abbot of Clairvaux, France, for enrolment into the Cistercian order. The abbey that they had erected, St Mary ad fontes, or 'at the waters' became anglicised to Fountains. This stereoscopic view *c.* 1898 is probably one of the earliest photographs taken of the ruins.

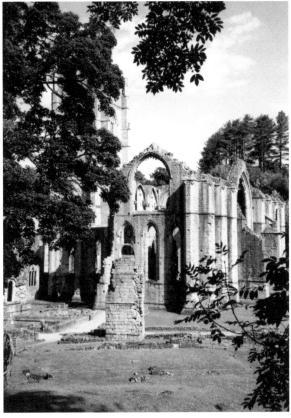

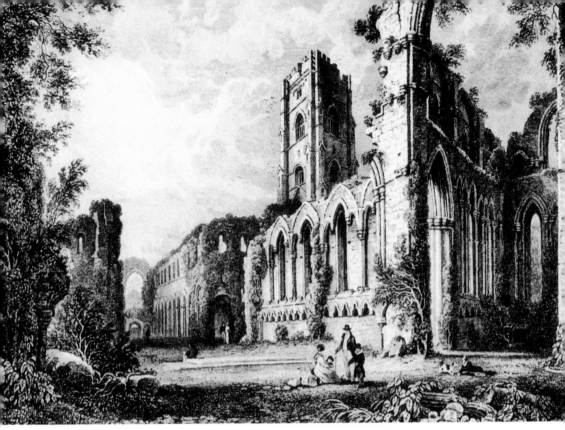

Artistic Views of Fountains Abbey

Before the invention of photography, the Romantic artists of the late eighteenth and early nineteenth centuries delighted in portraying ruined abbeys where vegetation sprouted from the crumbling masonry. This engraving of the interior of Fountains Abbey, published by R. Metcalfe of Ripon, illustrates a standard depiction looking down the thirteenth-century choir, where the Cistercian monks chanted and prayed, into the Norman nave where the lay brothers worshipped. Photograph from T. Sopwith's Eight Views of Fountains Abbey.

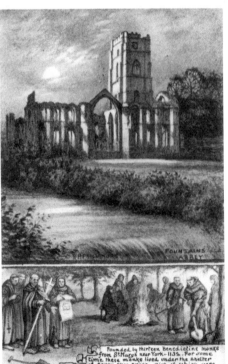

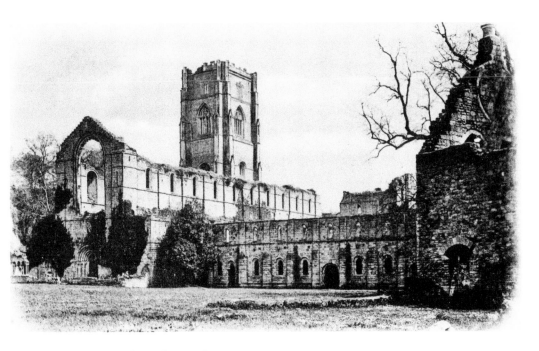

Fountains Abbey from the South-West

Yorkshire has the greatest collection of monasteries in the country, headed by a magnificent series of Cistercian abbeys. This order was founded in a desire to return to the simplicity and austerity of the early Benedictines. The monks renounced wealth and luxury and refused gifts of prosperous estates, seeking instead a frugal life of devotion and meditation in wild places. By the end of the twelfth century, over 100 Cistercian houses had been founded in England and Wales.

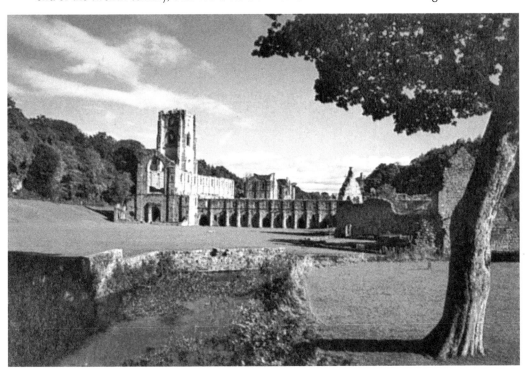

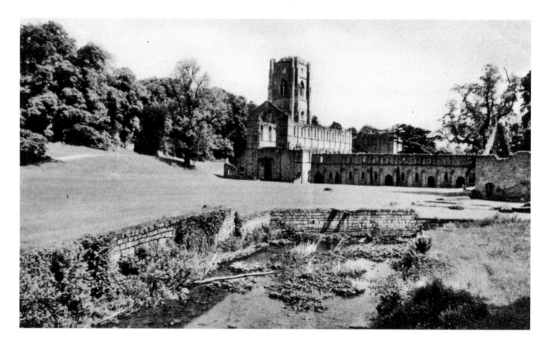

Fountains Abbey and the River Skell

The west front of the church and the west range – or as it is more commonly known, the Cellarium – with the River Skell in the foreground. In summer months, the waters recede almost to a trickle, but in winter after a thaw, the torrent can be quite something to behold. As fish was a staple diet of Cistercians, meat being prohibited, a supply of water to fill their fish ponds was a necessity. Some abbey sites were not as lucky, and had to drain their swampy valleys first.

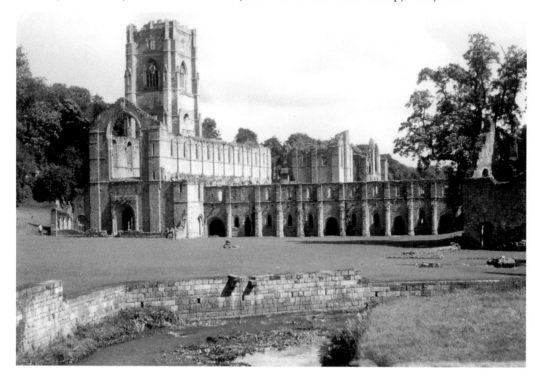

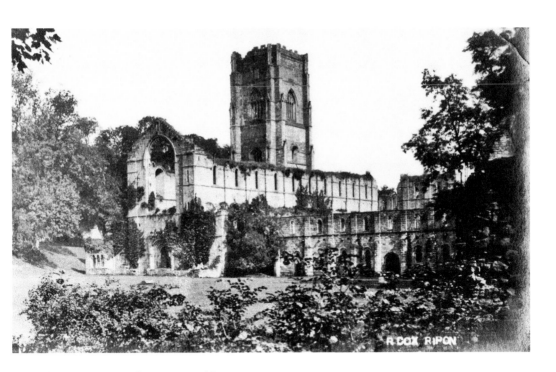

The West Front of Fountains Abbey

Each monastery was laid out to a standard plan, whereby the monks were separated from the much larger numbers of lay brothers who did the manual work and who worshipped in the western part of the church only at the beginning and end of each day. Before the catastrophe of the Black Death, lay brothers were essential to the running of the monastic economy. In an early view by local photographer R. Cox of Ripon, notice the vegetation beginning to be cut back on the coloured view.

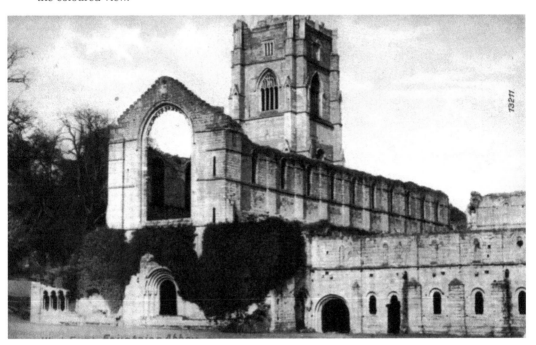

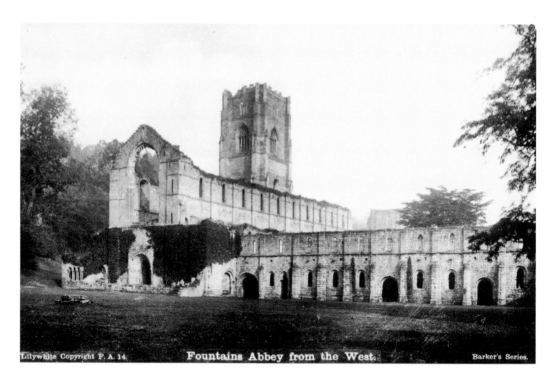

Fountains Abbey from the West.

Fountains Abbey from the West

Although it was completed over two decades, the west range of the rebuilt stone monastery is remarkable for its general uniformity of style. The ground floor of the earlier, northern end would have been hidden behind the high walls that enclosed the cellarer's yards to the west, and it would not have been obvious to medieval visitors that its small round-headed windows differed from the lancet windows that lit the lay brothers' refectory to the south.

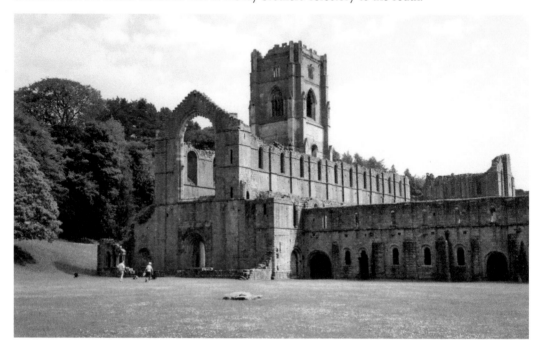

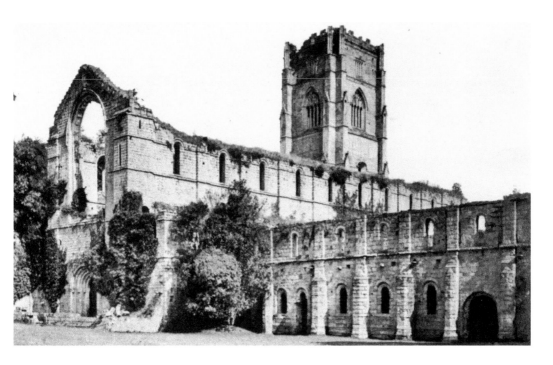

Fountains Abbey from the South-West

Two postcards of what is essentially the same view of Fountains, showing the great west window and part of the great Cellarium. The upper view by Photochrom Company, of Tunbridge Wells, shows as much vegetation as the bottom view, a more fanciful rendition by another famous postcard company – J. Salmon, of Sevenoaks. The painted view is by that well-known postcard artist A. R. Quinton. Both postcards predate the First World War.

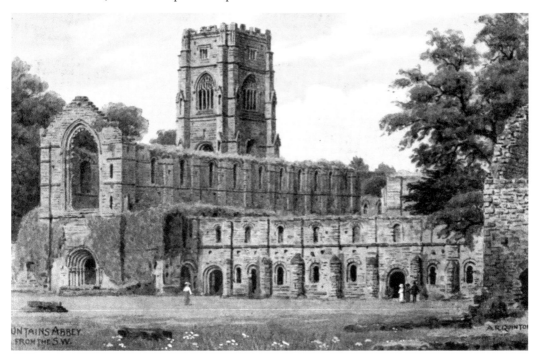

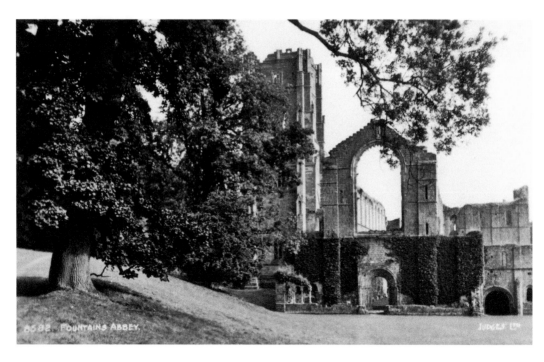

West Window, Fountains Abbey

Before the vegetation was eventually removed, it was at first carefully cut back and was no longer wild and untamed but manicured, as can be seen in this postcard view by Judges. Undoubtedly, this card represents a period when the ruins of Fountains were beginning to be opened for public enjoyment and the pruning was an attempt to make the romantic ruins more acceptable to public taste. Below, the great west façade bereft of all shrubbery.

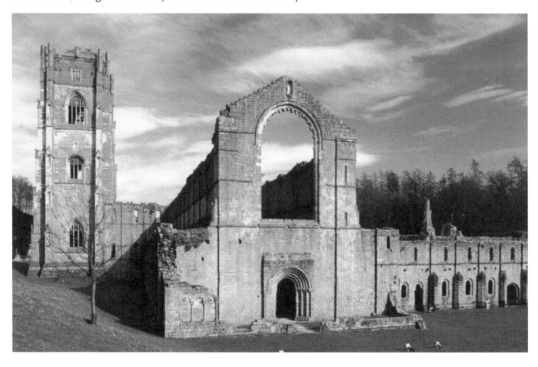

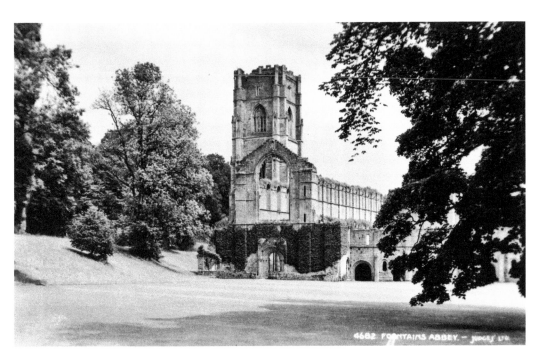

West Front and Huby's Tower, Fountains Abbey

Another early view of the west front depicted by the postcard firm of Judges of Hastings, showing growth, which was later removed. When Fountains was about thirty years old, it supported 140 monks and between five and six hundred lay brothers or *converse*; an astonishing number of devotees and far removed from the small band of thirteen monks who established it in those early decades. Below, the East Window.

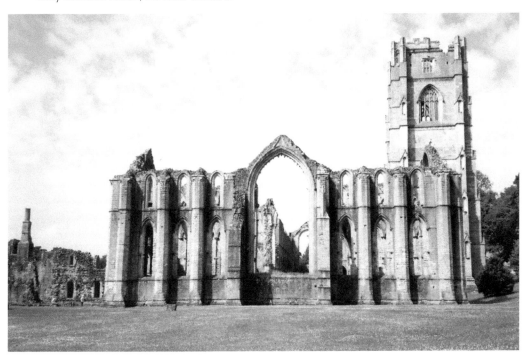

The Galilee, Fountains Abbey

The postcard view above of the Galilee, a covered porch before the west door, was perhaps the first view that the modern visitor would encounter and his first introduction to the architecture, so it was important to create a good first impression. The carefully cut back ivy in the upper view by an unknown postcard manufacturer is gone in the modern coloured view below.

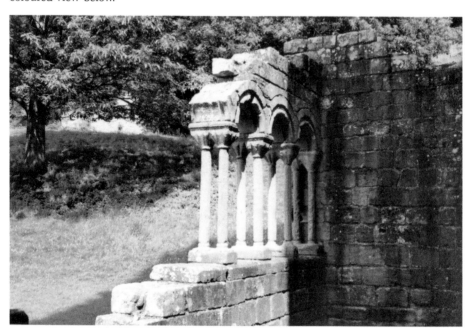

Remains of the Gatehouse, Fountains Abbey

Dating from the thirteenth century, it was here at the Gatehouse that a visitor would leave the bustle of the Outer Court behind and enter the calm of the Abbey's inner precinct. The porter, a respected monk, ensured that only male guests and those on authorised and verified abbey business would be able to pass through into the holiest of holies. Very little remains but at the least it would have been two storeys high. The ground floor would have one or more gated passages.

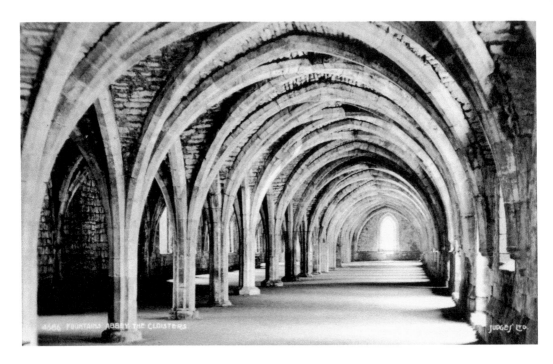

The Cellarium, Fountains Abbey

The Cellarium, or west range. Today there is a dramatic and powerful view along the entire length of this space, which would not have been possible at the time of Fountains Abbey. Amazingly, the Cellarium roof escaped Henry VIII's brutal sixteenth-century dissolution of the abbeys. Today, the only inhabitants are protected species of bats that live in the ceiling nooks and only come out after dusk. It is estimated there are over eight species of bat living in this covered space which provides shelter.

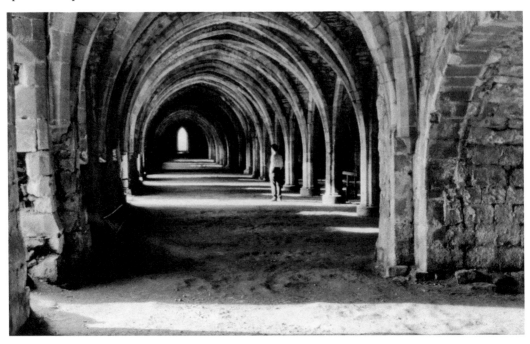

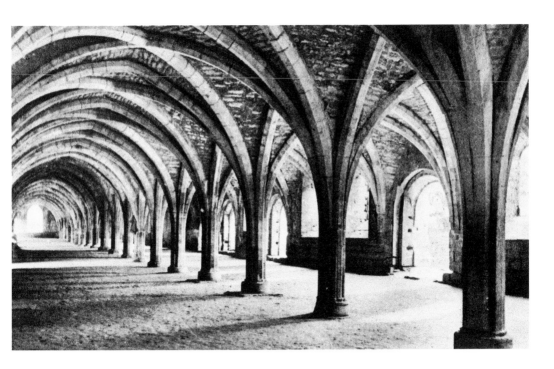

The Cellarium, Fountains Abbey

The vaulted space was divided into three areas; the midpoint would have contained the cellarer's parlour and from that point toward the church was a series of lockable store rooms for foodstuffs and wine. At the furthest end, the lay brothers ate their meals in their own refectory when working within the abbey bounds. The architecture dates from the twelfth century, though the farthest bays were reconstructed after they collapsed in the early nineteenth century. The work was completed under the stewardship of Abbot Pipewell, elected in 1170.

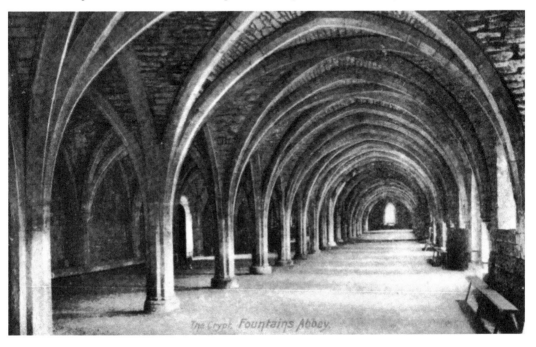

The Crypt. Fountains Abbey.

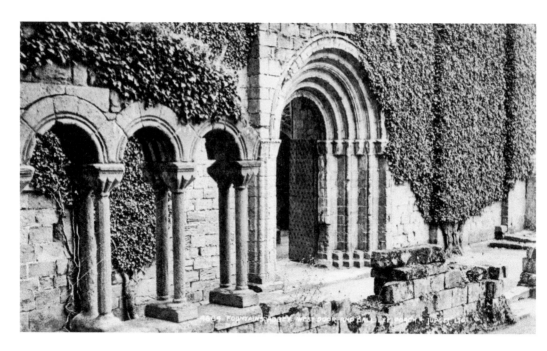

Fountains Abbey, West Door and Galilee

The Galilee is the westwards extension of a Minster church, taking the form of a chapel, porch or narthex. It usually seems to have consisted of a low pentise roof across the west end with an open colonnade facing outwards. Its use was possibly to have provided an assembly point or 'station' for monastic processions. Other uses have been suggested, including an annexe to which women might be admitted. The Galilee was a popular place for lay patrons to be buried before church burials were allowed.

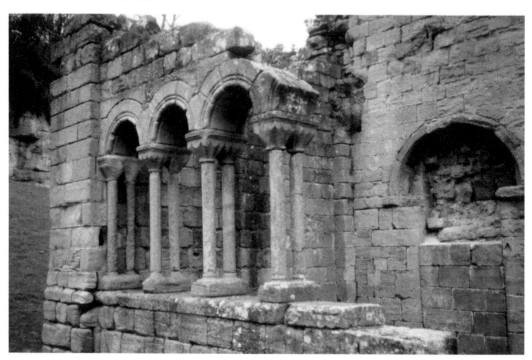

The Architecture, Fountains Abbey

Two phases of architecture are demonstrated in these two arches: the upper, a postcard by Wrench & Co., shows the great west door of the church at Fountains Abbey of Norman date, easy to spot as having a rounded head and sometimes referred to as of the Romanesque period (1066–1180); below, on the Judges postcard, a pointed arch inside the church from the early English period (1180–1280), sometimes referred to as a lancet when forming a window. The beauty of the pointed arch was that it was strong, but did not need to be as wide as a round-headed arch, which had limits – the wider the span the weaker it became at the head and more prone to collapse. Or if used in arcading it invariably meant less light and therefore a gloomy dark space. The Cistercian monks were among the first to adopt the use of pointed arches, and were using it freely by 1150, a considerable time before it was used in other ecclesiastical building.

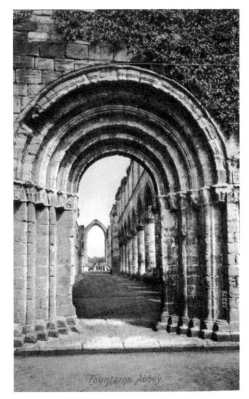

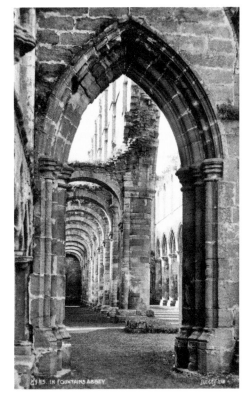

21

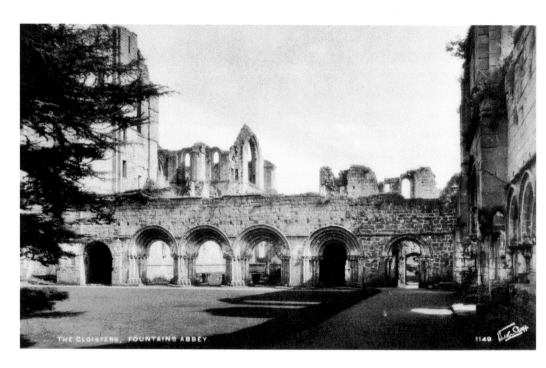

The Cloister Court, Fountains Abbey

The cloister (Claustrum) was the heart of a religious house, consisting of a rectangular walk, covered with a pentise (lean-to) roof, between the external walls of the main buildings and an arcaded wall (sometimes closed with shutters), which looked onto a grassy court or garden. The open arcades were sometimes glazed later. The favoured position of the cloister was on the south side of the nave but depending on the site could be for convenience on any wall.

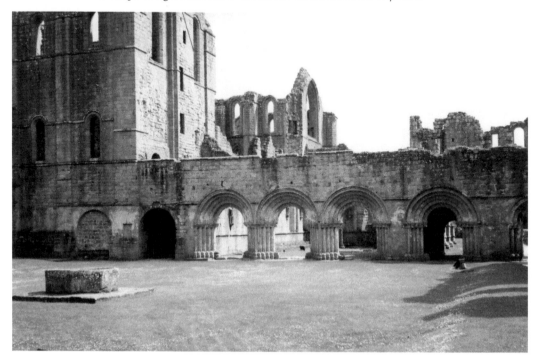

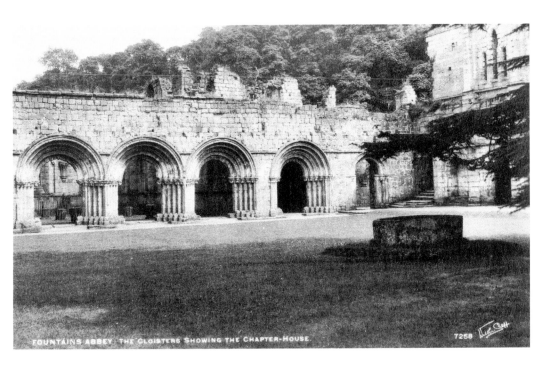

The Cloisters and Chapter House Entrance, Fountains Abbey

Above, a Walter Scott postcard showing the cloisters and the arched entrance to the chapter house, while below, this Valentine's card shows the cloisters from the opposite side. The cloisters were a covered walkway measuring some twenty-three feet internally, usually with a lean-to or pentise roof resting on an open-arched wall. Here the monks could exercise in bad weather and also move from their dormitories into the church without getting wet.

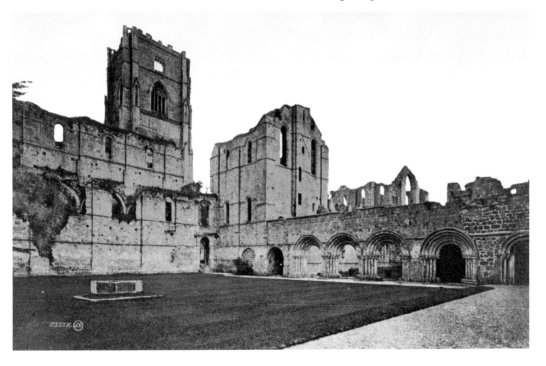

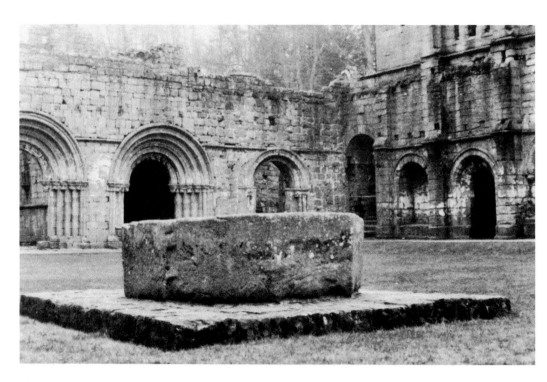

Cloister Court and Water Basin

The cloister, showing the basin thought to belong to the water system of the abbey, which is not in the original site. Water played an important role in any monastery and all well organised establishments were founded near a river. At Fountains, the course of the River Skell was altered and the old course turned into a natural drain with all toilets sited along its course so the flowing water would flush them clean.

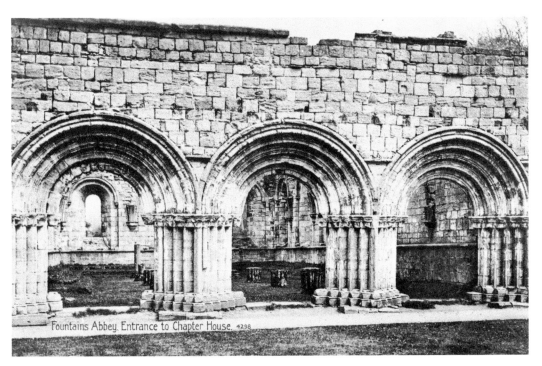

Fountains Abbey. Entrance to Chapter House. 4298

Entrance to the Chapter House, Fountains Abbey

The arched portals to the chapter house on this Valentine's XL series real photographic postcard. It was here in the chapter house, second only to the church in importance, that all the daily business of the monks was carried out, discipline was enforced and daily chapters of the Rule of St Benedict heard. Also in a silent order, as at Fountains Abbey, it was the only place where conversation was allowed. It was here, too, that important and distinguished visitors were often received.

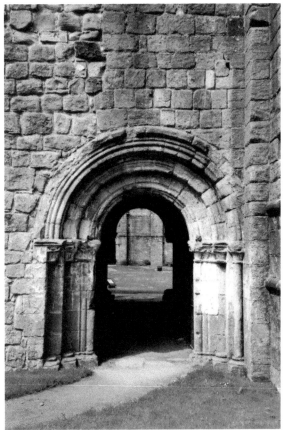

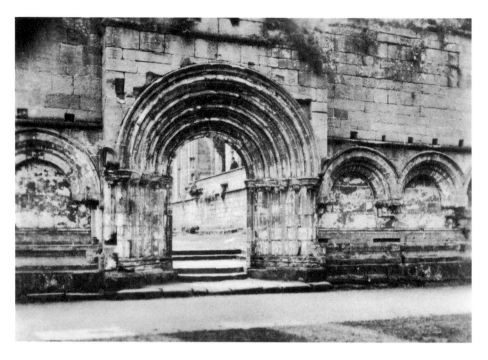

The Refectory Door, Fountains Abbey

A view of the refectory doorway from the cloisters; sometimes known as the frater, it was the common dining room of a monastery, and behaviour and food were governed by strict rules. The monks would arrive in procession, wash in the nearby laver (on the bottom side of the cloister), take their place in order, sing grace and then eat in silence while a monk (appointed for the week) read aloud from the pulpit. Below, the gable end remains of Abbot Pipewell's infirmary.

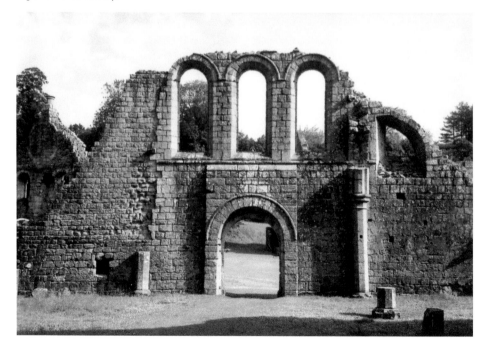

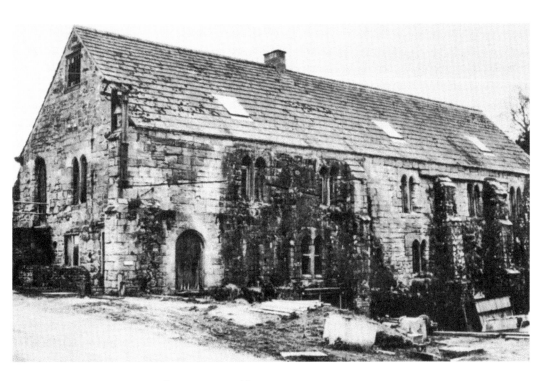

The Water-Powered Mill, Fountains Abbey

The watermill at Fountains is said to be the finest surviving example of a monastic corn mill in England. It appears to date from the thirteenth century, but masonry of an earlier date has been incorporated. Archaeological examination has revealed that there were no fewer than three distinct buildings. The lower storey, which has the wheel at its southern end, was driven via the mill race that still remains. It was worked commercially up until 1937, and is now a museum.

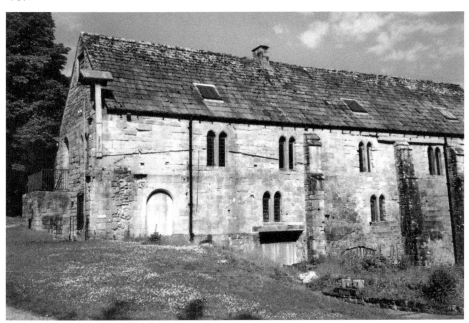

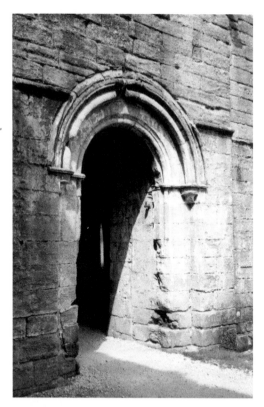

Architecture and Doorways

The top door is from an early period, dating from around the 1140s, part of the parlour walk. Below, the view is looking from Abbot Murdac's east cloister range through the western range. This part of Fountains Abbey can be identified by its small, roughly squared blocks of gritstone with wide mortar joints. There are remains of thick external white-limed plaster, while the plain doors and windows are in good quality ashlar stone. Interestingly, it wasn't until I looked at the photograph that I realised there appears to me to be a face on the central voussoir stone partly turned to face inward. Possibly this is a reused carved piece?

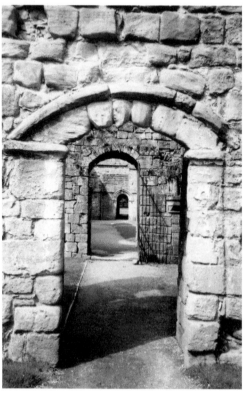

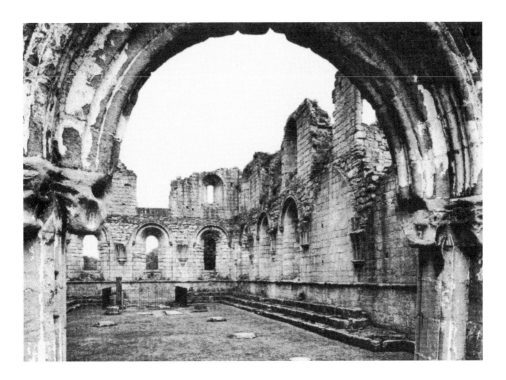

The Chapter House, Fountains Abbey

The shattered remains of Richard of Clairvaux's chapter house retain the bases of its marble piers. Within the railings at the east end are the graves of the abbots, starting with Richard himself, and including Robert of Pipewell, William of Newminster, Ralph Raget, John of York and John of Kent. It must have been a low, dark room, as its ceiling was only seven feet above ground level. Below, a fine façade with a row of lancet windows of twelfth-century date.

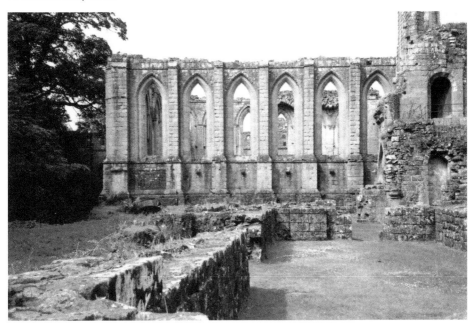

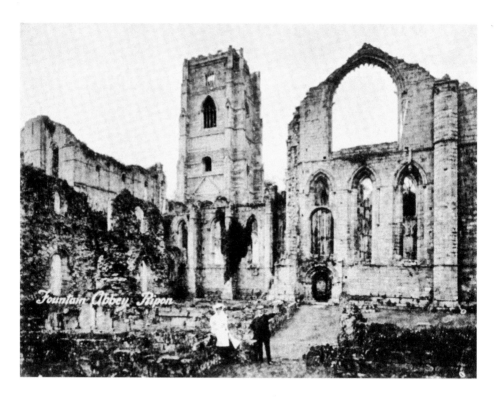

Fountains Abbey and Huby's Tower

This couple of professional 'models' appear in no less than three separate postcard views of Fountains Abbey issued by the Christian Novel Publishing Company, who employed postcards as an early form of advertising and 'the beautiful series of fine art [coloured] postcards' below were supplied free, adding further, 'For pure reading matter Christian Novels is the World's best.' A somewhat grandiose statement, which overlooks Christ's teachings to be humble in all things! The top card is black and white and was posted in 1906.

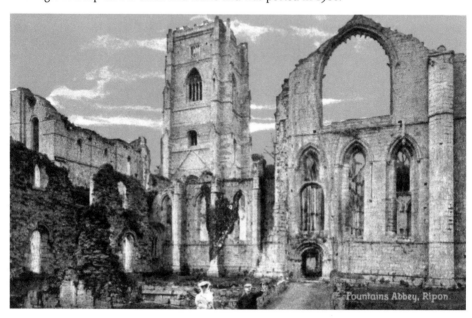

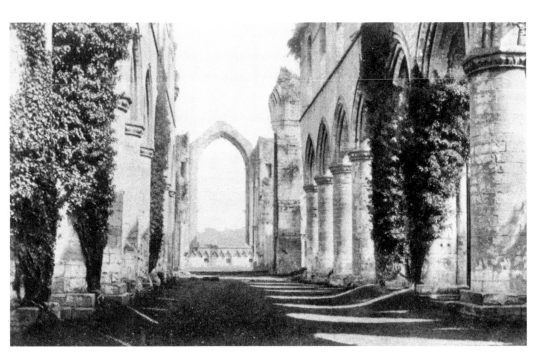

East Window, Fountains Abbey

Originally, the church was constructed of wood by the small band of monks, and later replaced with a modest stone one. Some years later came the great abbey church with its imposing west front, which masons completed around 1160 using the sandstone cut from the cliffs on the valley side. This part of the church, the nave, was used by the lay brothers. These two early views showing vegetation creeping round the stone columns date from *c.* 1902, dated by the postmark.

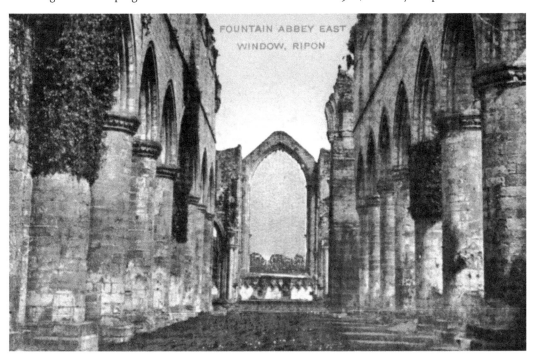

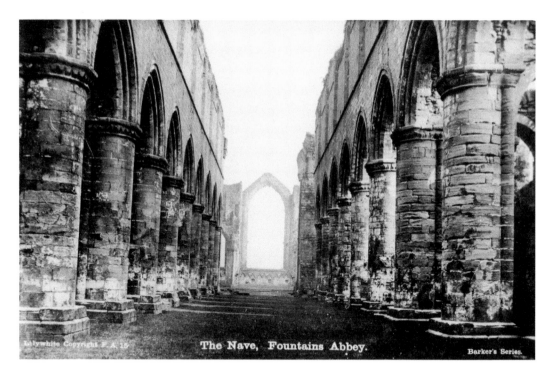

The Nave, Fountains Abbey.

The Nave Looking East, Fountains Abbey

Work began on building the nave in the late 1150s, and provision was made for a central tower. The crossing tower built at Fountains was completed as a great lantern to throw light into the choir area, for it should be remembered that the nave would not be a vast open hall as seen today. The great length – the longest of all the Cistercian monasteries in England – would have been divided into special areas with a series of wooden screens blocking a great deal of light.

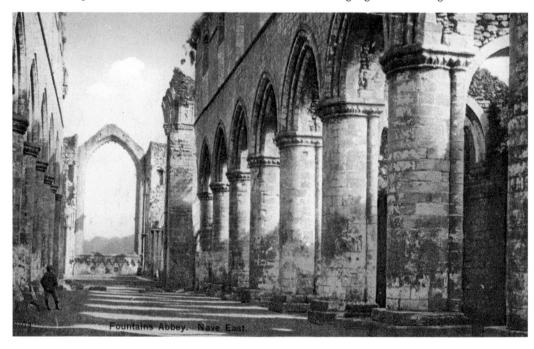

Fountains Abbey. Nave East.

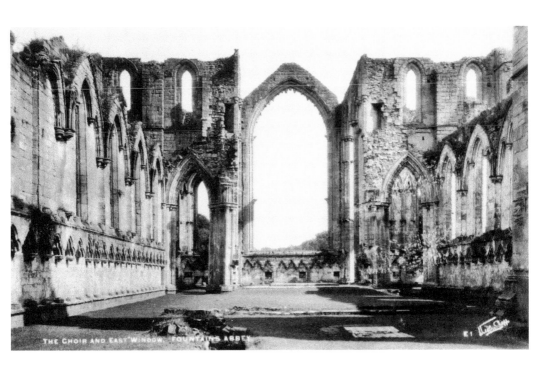

Fountains Abbey, Choir and East Window

The choir was for the use of the monks only, and was cut off from the nave by a wooden screen. The first Cistercian monks led austere lives. Most of their day was spent in silence, though they could communicate with signs when necessary. Seven times each day, the service bell called them to prayer, from the first at daybreak to Compline at dusk, then Vigils at two o'clock in the morning. Below, detail of arcading.

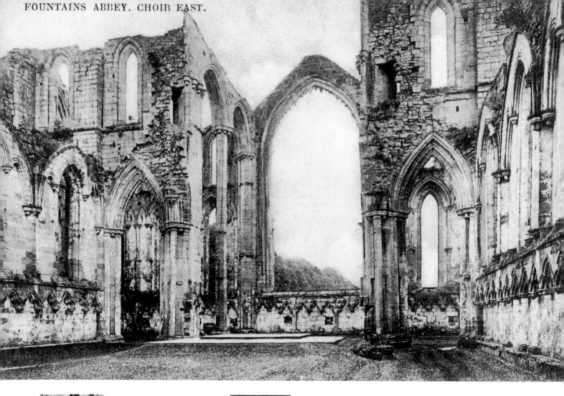

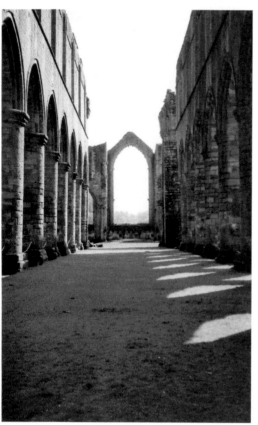

The Choir Looking East, Fountains Abbey
The nave, which demonstrates a radical change in design, was not built at the same time as the transepts, but shortly after. Presumably, the old nave survived in use to house the altar and monks' choir while the eastern part of the new church was being erected. Only when the eastern parts of the new church were substantially completed could it be demolished and a new nave built in the 1150s.

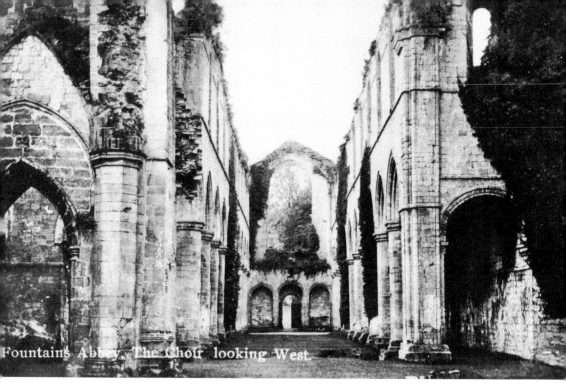

Fountains Abbey. The Choir looking West.

The Choir Looking West, Fountains Abbey

During the time of Abbot Huby, new choir-stalls were provided for the thirty or so monks who now occupied the abbey. The stalls are gone, but were probably the work of the Bromflete family of Ripon. Their site is marked by stone-lined pits (now reburied), which comprised a hollow space below the wooden floor of the stalls to give more resonance to the singing. This effect was further heightened in the northern bank of stalls by the inclusion of open-necked pottery jars in the stone lining of the pit.

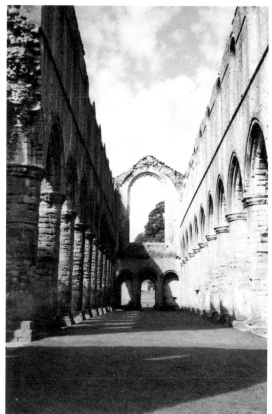

35

The Burial Site, Fountains Abbey

In the monks' choir in the abbey church of Fountains lies a broken slab of grey marble, 9 foot 2 inches long, and 4 foot 7½ inches wide, with the casement of the brass of an abbot. The figure, which was 4 foot 7½ inches high, stood beneath a crocketed canopy with a trefoil arch, supported by pinnacled side shafts. The slab at Fountains, according to Mr Walbran, was discovered in 1840 by some workmen employed in the abbey, who were anxious to find hidden treasure. Part of it was then taken up and found to cover a grave containing a skeleton. Although the brass insets have been plundered and the stone broken by Walbrun's labourers, the outline of the abbot's figure with a mitre above his head and below a canopy can still be observed. The interest of the slab lies in the detached mitre ... The placing of the mitre in such a position is no doubt a reference to Abbot Thomas Swinton's resignation in 1478.

Mill Stephenson 'Monumental Brasses in the West Riding', YAJ, Vol.15 1900

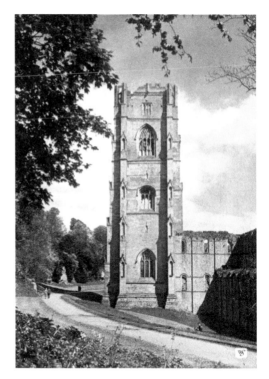

Huby's Tower, Fountains Abbey

Towers had originally been forbidden by the general Chapter of the Cistercian Order, but that proscription began to weaken as Cistercian architecture developed. In 1157, the General Chapter amended the statutes to the effect that 'stone towers with bells [should] not be built'. However, by the time Abbot Marmaduke Huby ordered this tower to be erected around 1500, the spirituality of the monks had so degenerated that no one took notice. Huby built this great 167-foot tower as a statement of power and vanity. Abbot Huby was one of the abbey's greatest abbots and was almost the last. Huby's tower was constructed from the local limestone, and had Latin inscriptions in praise of God carved high up on its outer faces. Stone carvings and statues graced the windows, again banned in earlier years; however, some niches appear never to have been filled. These two postcard views show the tower from the crossing where it terminates at the north transept, while the other below shows its external west face.

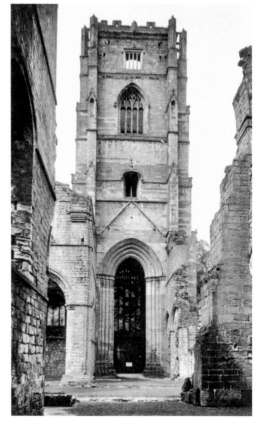

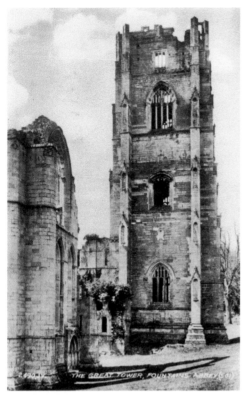

The Great Tower, Fountains Abbey

Huby's first plan seems to have been to build a new crossing tower and repairs and strengthening took place. However, presumably on advice, he had his new tower sited at the end of the north transept. The scale and design of this new tower amply demonstrated Fountains' importance as the pre-eminent Cistercian house in England and the status of Abbot Huby, that 'golden and unbreakable column in his zeal for the order'. On the south face above the lowest window is the statue of an abbot without a mitre, perhaps St Bernard, while above the lowest window of the north face is St Catherine and above the second window St James the Great. The statues above the lowest windows on the east and west faces of the tower are angels holding shields, that on the east bearing the three horseshoes of Fountains, that on the west the mitre, staff and initials of Huby himself. Bands of black-letter inscription two feet high were placed below the parapet and beneath the upper two tiers of windows, comprising Latin texts taken from the Cistercian breviary.

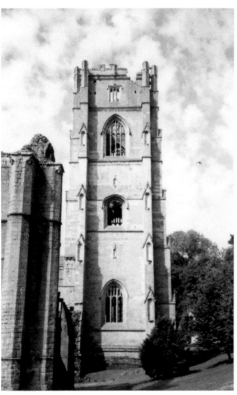

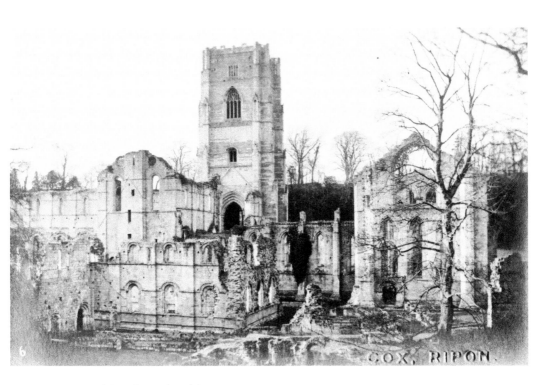

Fountains Abbey from the Abbots' House

This was one of the earliest areas of Fountains Abbey to be properly excavated under the direction of Richard Walbran. After his archaeological work, a great deal of fallen debris was taken away and this area began to take on its present-day appearance. In the foreground of the upper postcard by Cox of Ripon, it is just possible to see the basement of the abbots' house, excavated by Walbran in 1850. His systematic work began to reveal parts of the monastery lost to view since the seventeenth century.

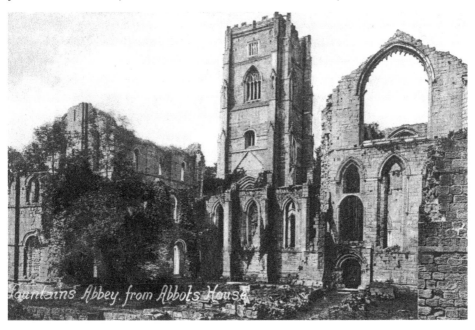

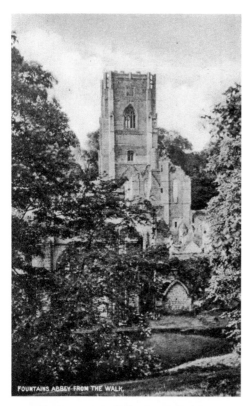

FOUNTAINS ABBEY-FROM THE WALK.

Fountains Abbey from the Walk

Two views of Huby's tower from the 'Walk', a perambulation around the grounds created when Mr Aislabie had the estate landscaped. Externally, it is divided into four storeys by string-courses that correspond approximately to its internal floors, and is topped by an embattled parapet, which originally had tall pinnacles at the angles standing on the buttresses and connected to the wall-head by miniature flying buttresses, with small pinnacles corbelled out from the parapet in the middle of each side. The windows of each stage vary: the ground and second floors have standard Perpendicular traceried windows with pointed heads that would have matched closely Abbot Darnton's new windows in the church itself. The first floor has similar windows with elliptical heads, and the fourth floor has three-light windows with square heads. The bellchamber occupied the third floor and its windows were closed with wooden louvres, otherwise all the windows were glazed. The proportions of the tower are enhanced by its decoration.

Fountains Abbey.

The Bakehouse, Fountains Abbey

Above, a view of the bakehouse with a trough in the foreground and unexcavated sites beyond. These industrial buildings are now under re-evaluation due to modern excavation work and it is now thought this building had a variety of functions, as a large aisled hall in the twelfth century, which underwent many modifications including use as a smithy, and it is in some doubt whether it is ovens or furnaces we see. There was a disastrous fire here in 1146 causing much damage and rebuilding.

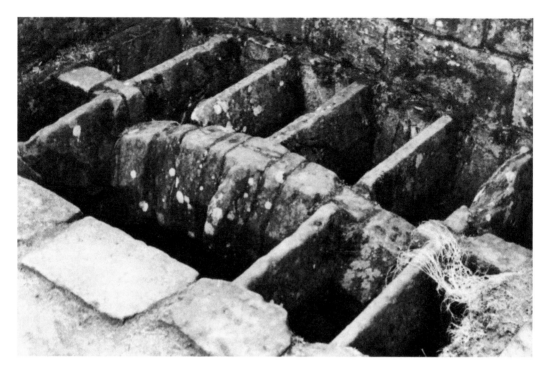

Monks' Kitchen & Kitchen Latrines, Fountains Abbey

The last part of the south range to be rebuilt was the kitchen. A round-headed opening to the monks' refectory was not a door; instead the opening was originally fitted with a circular dumb-waiter revolving on a pivot. At the centre of the kitchen were two great fireplaces set back-to-back. In one corner was a stone grid 8 feet by 6 feet – the covering of a waste chute that led directly to Skell, and nearby was a small latrine block for the use of kitchen staff (below).

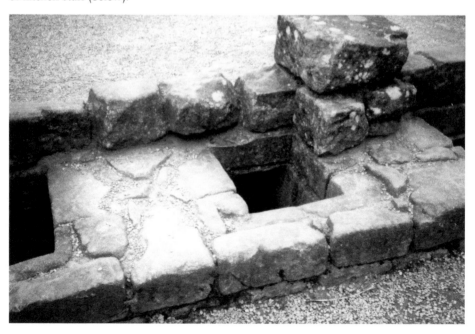

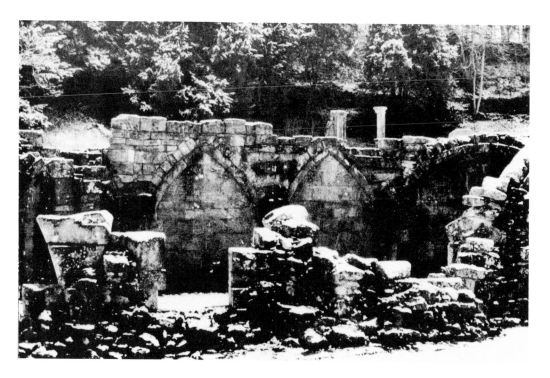

Cellar of the Infirmary Chambers

The softening of monastic life can best be seen in the way the infirmary buildings were adapted. The easier lifestyle of the infirmary was more to the taste of Abbot Ayling, who resigned in 1279. Old and sick monks had always been allowed richer food than the rest of the community and this included both meat and eggs, prohibited in the refectory, and so he had a corner converted to a private residence. Later, the monks took over and they too made private cells for their accommodation.

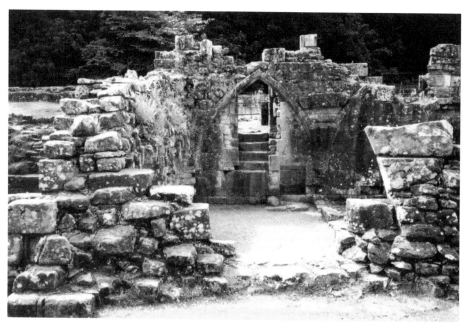

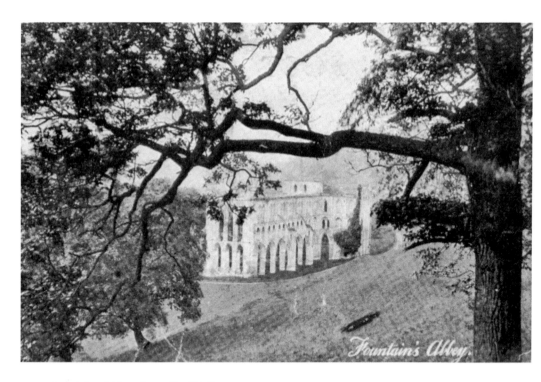

Fountains Abbey from the Walk

Pleasing walks through the trees for visitors were laid as early as 1755 by William Aislabie, the most famous is that which lead to the Surprise View, later extended by his daughter, Mrs Allanson, in the 1790s. Overgrown trees almost completely obscured the outlook when the National Trust took over in 1983. The ongoing challenge for the gardeners was to recreate the eighteenth-century views as trees continue to grow, mature and die. A continuous scheme of under-planting has been developed, with trees and shrubs growing ready to fill gaps.

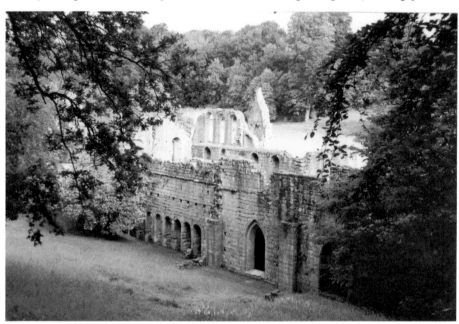

Through the Nine Altars Arch

Architecturally, the Chapel of Nine Altars continued the design of the presbytery, though its detailing shows a degree of development. Each bay had a lancet window flanked by blind arcading set over a continuous wall arcade that matched those of the presbytery aisles, with a similar arrangement in the clerestory fronted by a wall passage and gallery. In the eastern gable of the church, in place of the three central lancets of the clerestory, was a great rose window, removed in 1483 by Abbot Darnton, which balanced Richard of Clairvaux's circular window in the west gable of the nave. The design of the rose window was reflected in the multicoloured mosaic tile floor that was then laid in the presbytery and Nine Altars, fragments of which can still be seen reset in the platform of the high altar. Sadly, no major areas of Abbot John's pavements from after 1236 have survived in place. This is particularly unfortunate for they are likely to have been the first use of mosaic tiles by the Cistercians in northern England.

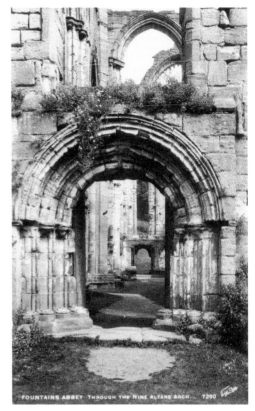

FOUNTAINS ABBEY. THROUGH THE NINE ALTARS ARCH. 7290

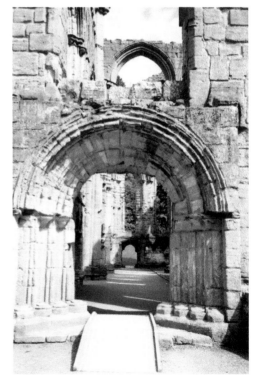

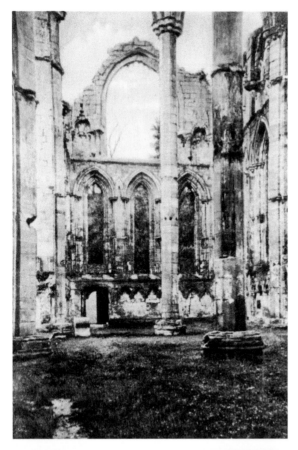

Chapel of the Nine Altars

The Chapel of the Nine Altars was the contribution of Abbot John of Kent along with an eastern transept to the east of the new presbytery. The chapel provided nine private chapels along its eastern wall, which were used by ordained priests to say Mass on request or payment for the wealthy or important. The building work dates mostly from the mid-1200s, though it was partially rebuilt and repaired two centuries later. This remarkable building remains virtually intact apart from its roof and vaults. It has no Cistercian model, indeed, the only comparable building is the east transept of the Benedictine Priory of Durham (now the Cathedral) begun in 1242 as a copy of the Fountains example. The great window and carvings, including a 'Green Man' are from the time of Abbot Darnton. The lofty and impressive columns were once clad in local 'Nidderdale Marble', a limestone that polishes to a rich, dark grey.

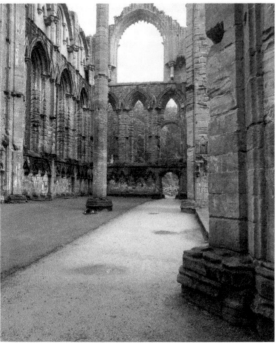

Abbots of Fountains Abbey

Name, brief resume of careers, if known, dates of abbacies. Names not numbered were felt to have ruled unwisely or brought the monastery into disrepute.

1 Richard I, Prior of York 1132–39
2 Richard II, Sacrist of York, Prior of Fountains, 1139–43
3 Henry Murdac, abbot of Vauclair, Archbishop of York 1147, died 1153, 1144–47
Maurice, sub-Prior of Durham, Abbot of Rievaulx, resigned 1147/48
Thorold, monk of Rievaulx, resigned, became Abbot of Trois Fontaines, 1148–50
4 Richard III, Precentor of Clairvaux, Abbot of Vauclair, 1150–70
5 Robert of Pipewell, Abbot of Pipewell, 1170–80
6 William of Newminster, canon of Guisborough, Abbot of New Minster, 1180–90
7 Ralph Haget, Abbot of Kirkstall, 1190–1203
8 John ofYork, cellarer of Fountains Abbey, Abbot of Louth Park, 1203–1211
9 John ofHessle, became Bishop of Ely, 1211–1220
10 John of Kent, cellarer of Fountains Abbey, 1220–47
11 Stephen of Eston, cellarer of Fountains, Abbot of Sawley, Abbot of Newminster, 1247–52
12 William ofAllerton, Prior of Fountains Abbey, 1253–58
13 Adam, 1258–59
14 Alexander, 1259–65
15 Reginald, 1265–74
Peter Ayling, resigned 1279, died 1282, 1274–1279
16 Nicholas, 1279

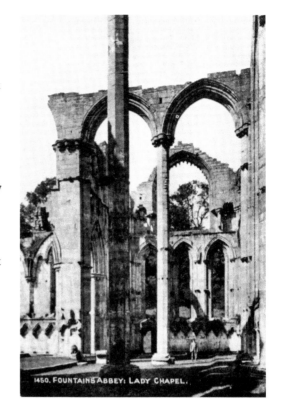

1450. FOUNTAINS ABBEY: LADY CHAPEL.

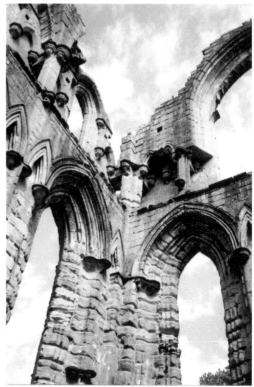

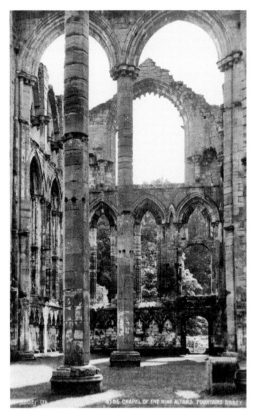

Abbots of Fountains Abbey

17 Adam Ravensworth, 1280–84

Henry Otley, probably resigned 1289, died 1290, 1284–89

Robert Thornton, probably resigned 1290, died 1306, 1289–90

18 Robert Bishopton, 1290–1311

19 William Rigton, 1311–16

20 Walter Coxwold, resigned 1336, died 1338, 1316–36

21 Robert Copgrove, 1336–46

22 Robert Monkton, 1346–69

23 William Gower, resigned 1384, died 1390, 1369–84

24 Robert Burley, 1384–1410

Roger Frank, monk of Fountains, deposed 1413, 1410–13

25 John Ripon, cellarer, Fountains, Abbot of Meaux, 1414–35

26 Thomas Paslew, resigned 1442, died 1443, 1435–42

27 John Martin, 1442

28 John Greenwell, monk of Fountains, Abbot of Waverley, Commissary of the Abbot of Citeaux, 1442–71

29 Thomas Swinton, Prior of Fountains, resigned 1478, 1471–78

30 John Darnton, cellarer of Fountains, Commissary of the Abbot of Citeaux, 1479–95

31 Marmaduke Huby, monk, bursar & cellarer of Fountains, master of St Mary Magdalene hospital, and Commissary of the Abbot of Citeaux, 1495–1526

32 William Thirsk, Commissary of Abbot of Citeaux, resigned 1536, executed 1537, 1526–36

33 Marmaduke Bradley, monk of Fountains, Prebendary of Thorpe, master of St Mary Magdalene hospital, surrendered his abbey to the Crown in 1539, died 1553, 1536–39

Fountains Abbey dissolved by Henry VIII and sold off.

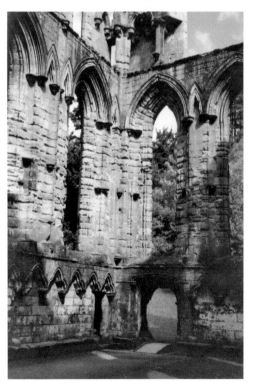

The Church Aisles, Fountains

Following the erection of the first church
at Fountains, it was soon evident a newer
and more imposing church was required.
Abbot Richard III began it and building work
continued until 1174. The new church has a
complicated structural history due partly to
it being erected around its predecessor. The
nave aisles were vaulted transversely, carrying
back the profile of the nave arcades to the
side walls, a feature designed to support
the thrust of a high vault, but the roof was
not vaulted in stone but roofed in wood.
Cylindrical piers rose from moulded bases
and were capped with scalloped capitals that
carried moulded arcades of two orders, and
the corbels, which carried the transverse
arches across the aisles, were decorated in
fine Anglo-Norman waterleaf detail. These
were the first beginnings of architectural
decoration in any English Cistercian church.
The south aisle wall was completed to close
off the cloister. Work was then temporarily
halted and was not resumed until Abbot
Robert of Pipewell completed the church and
provided a choir for the lay brothers.

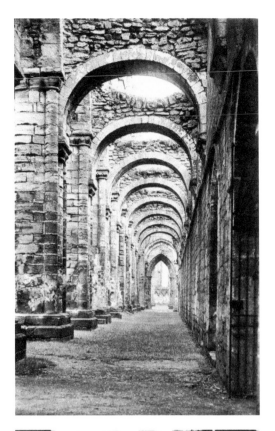

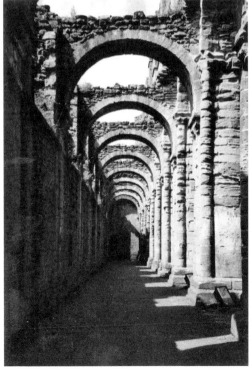

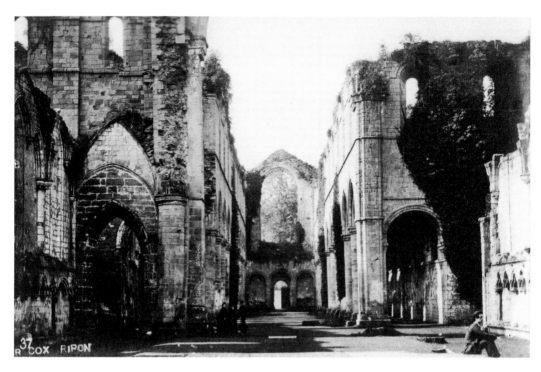

Choir and Nave, Fountains Abbey

Although the nave and transepts are now an uninterrupted space, this was not the case originally and the church was divided into a series of distinct functional compartments. This partitioning shows clearly how a major Cistercian church was used, divided between the two 'churches' of the lay brothers and the choir monks. The seven western bays of the nave comprised the lay brothers' church and cuts in the seventh piers from the west indicate the position of the rood screen against which the nave altar was placed.

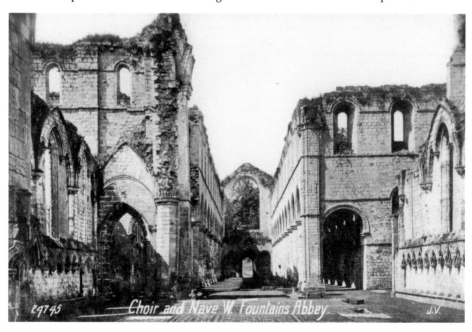

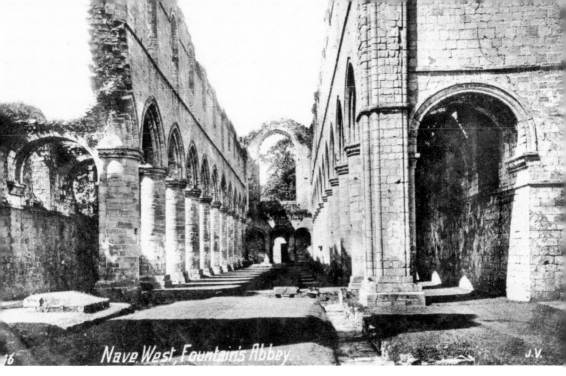

Nave West, Fountains Abbey

The Nave Looking West, Fountains Abbey

Between the first and sixth piers of the nave, stone screen walls were provided against which the lay brothers' choir stalls were placed. The aisles were simply corridors providing access to the eastern parts of the church and its chapels. Beyond the rood screen the monks' church began. The eighth bay of the nave served as their retro-choir where the old and infirm were allowed to sit during services, in greater comfort than in the choir. The next bay was taken up by the pulpitum.

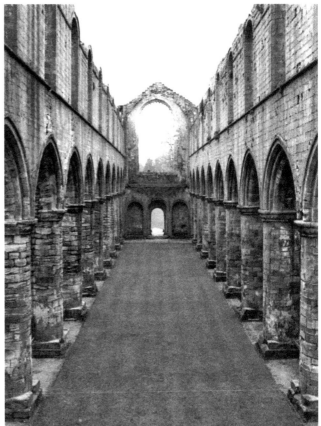

Refectory, Fountains Abbey
Above is the sculptured corbel supporting the reading pulpit in the refectory. The Prior was to preside over the convent's meals, twice a day in summer and once in winter. Meals were taken in silence, only interrupted by readings from the Bible. A round-headed door in the west wall led to a stair in the thickness of the wall that gave access to a passage and the huge reader's pulpit on the right, carried on a great foliate corbel that still remains (see page 53).

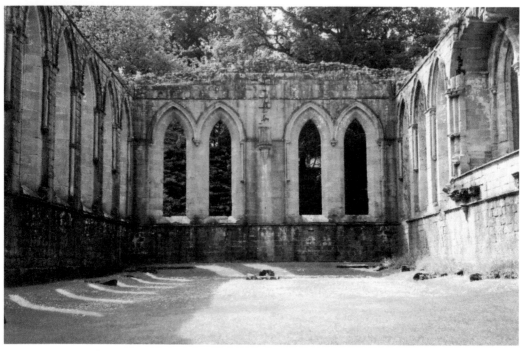

The Refectory, Fountains Abbey

The refectory, a remarkable chamber, was conceived as a building of five double bays with a central arcade, each bay lit by a pair of tall lancet windows. It was erected between 1180 and 1210. Its length posed a problem because the old yard to the south of Murdac's refectory in which it was built was bounded to the south again by the river, leaving insufficient space for the new building. The river could not be moved for it flushed both the lay brothers' and monks' latrines, and the only solution was to build the southernmost half-bay of the building over the river on a tunnel. Within, the new refectory was an impressive building, open to the roof and divided down its centre by an arcade. As originally built, the refectory was roofed in two spans, and each span was lit by a circular window in its southern gable. Later, the roof was altered to one of a single span and lower pitch in the fifteenth century but otherwise the refectory retains its original detailing. The walls were whitewashed and lined out in white paint to resemble ashlar masonry.

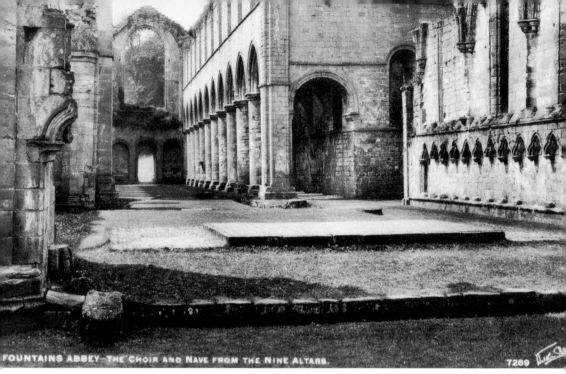

FOUNTAINS ABBEY—THE CHOIR AND NAVE FROM THE NINE ALTARS. 7269

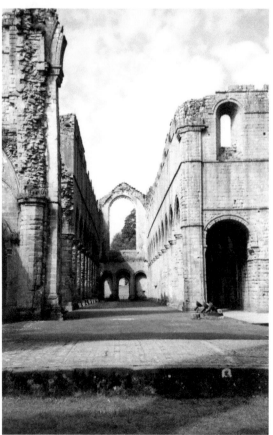

Site of the High Altar, Fountains Abbey

The typical Cistercian church, with its low elevation, its plain, bare walls, lit by few windows and without stained glass, achieved its effect by the balance of masses and austere, powerful, round or pointed arches and mighty vaulting. These buildings filled anyone who entered them with peace and restfulness and disposed the soul for contemplation in an atmosphere of simplicity and poverty. St Benedict's doctrine on humility, the basis of his teaching, was written out before them in stone. 'The Waters of Siloe', Thomas Merton, 1950.

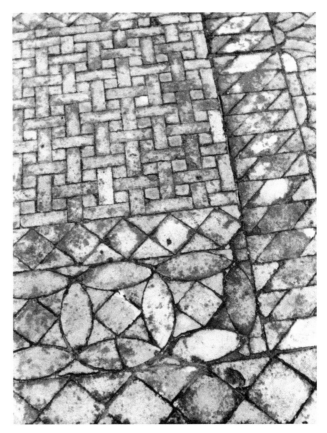

Medieval Tile Flooring, Fountains Abbey

In contrast to some Northern monastic churches, particularly Byland Abbey, the floor of Fountains Abbey was tiled quite modestly. Much of it has disappeared and only a few paved areas remain. Above and below are examples of thirteenth-century tessellated tile work; though on the site of the altar, the tiles were placed here in the 1770s from the remains of original paving found in the church. At Byland the colour scheme is a blaze of rich greens and yellows, but here the colouring is more subtle.

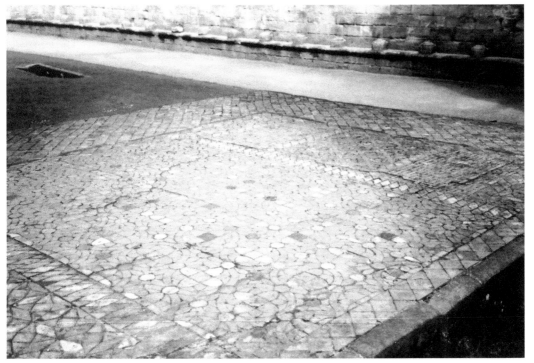

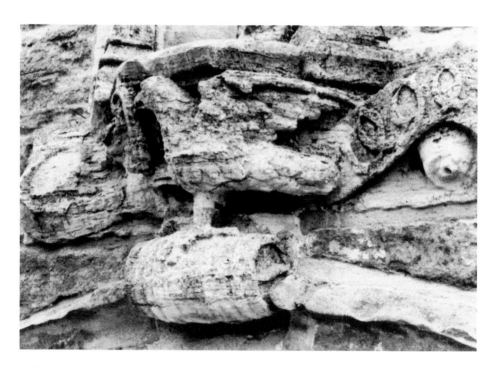

Abbot John Darnton's Rebus, Fountains Abbey

Above, the rebus (a pictorial representation) of Abbot John Darnton on a corbel above the great west window. The name John is represented in the eagle of St John, the word 'dern' is now almost obliterated but was on the left part of the scroll, and 'ton' is the name for a cask, held by the eagle. The eagle also holds a crozier, and the inscription to the right reads 1494. The whole corbel supports a headless statue of the Virgin Mary. Below, an almost obliterated inscription on Huby's tower.

Rebus of Abbot Darnton and the Green Man

By the second half of the fifteenth century, the structure of the church was beginning to show its age. Abbot Darnton inherited a church that was distinctly old-fashioned and showing signs of instability. Stresses from the crossing tower and the presbytery had caused the south-eastern crossing pier to deform and a huge buttress had been built to support it. Darnton found the south-east corner of the Chapel of the Nine Altars was so unstable as to require shoring up. Where the masonry had faulted over windows he inserted stitches of new stone. A gap in the head of the north window of the east wall of the Nine Altars was patched with a stone carved with the head of a 'green man' (below) and an angel carrying a scroll with the date 1483, while a repair to a window of the south wall was hidden with a carved rebus. The angel has dem [dam] on his breast and the date 1494, and the eagle [emblem of St John] and tun [name for a barrel]. This pun or rebus on the name John Darnton is effectively his signature on the completion of the work.

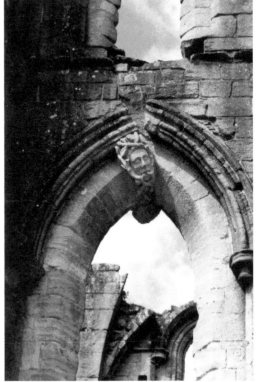

Lay Brothers' Reredorter, Fountains Abbey

A large corbel in the wall of the lay brothers' reredorter, at the intersection of the infirmary, helps support a covered way or pentise, and the groove in the wall marks the roof line. A pentise is defined architecturally as a passage or corridor running along the side of a building, its single pitch (or pent) roof carried on corbels in the wall of that building. Such corridors were normally of light construction and often left very little trace. The tree seen in the two views appears timeless.

Monk's Dormitory Range and Guest House Range

The rebuilt monk's dormitory range incorporates in its lower walling the greater part of the pre-fire range. The southern end of the range comprised the unheated dayroom. A central row of pillars (above) originally supported a groined vault on which the floor of the monks' dormitory was carried. Below the columns of the guest house hall survive. These ground floor suites were vaulted but of inferior quality to those on the upper floor. Indeed, the stone columns are notched to suggest that the vaulting was of wood, or had to be supported by timber resting against the columns.

59

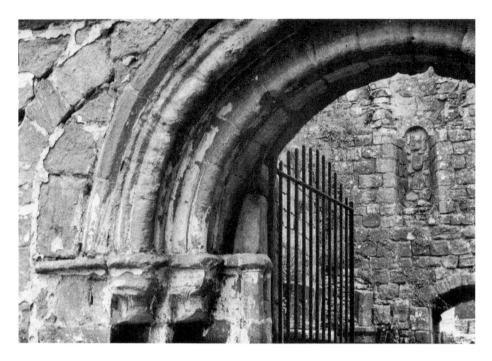

Entrance to Dormitory Undercroft, Fountains Abbey

A new dormitory replaced an older one. It provided sufficient space for 120 monks, with their beds placed along the walls and the central part of the room taken up by wooden clothes presses. The raised height of the dormitory floor made the original night-stair to the church unusable, and a new round-headed door was created. In the wall to the right a narrow, blocked round-headed window can be seen, which gave light to an earlier twelfth-century day-stairs and dormitory.

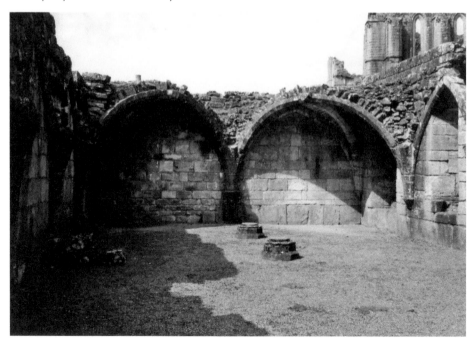

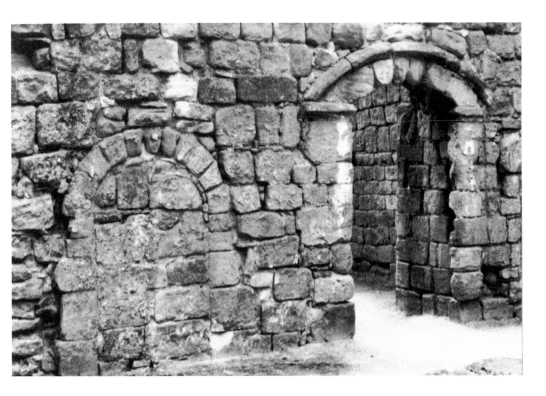

Infirmary Entrance, Fountains Abbey

In a building of such age and complexity, rebuilt many times, it is not unusual to come across blocked doorways and passages. Above, a doorway to the infirmary in the undercroft wall. The blocked doorway led into an earlier passage to the infirmary. Below, blocked doorways and arches in the exterior of the water-powered mill. The larger arch was at one time an outlet for a mill race to turn a water wheel, but blocked when the interior arrangement changed, making the wheel redundant.

South Transept Chapels, Fountains Abbey

Above, the interior of the south transept chapels. The original of around 1150–60, and at the top, the fifteenth-century extension breaks into the circular window. Notice the doorway to the left. From the outside, the south transept chapels; the north chapel window (left) dates from the earliest period, the south chapel (right) has the fifteenth-century extension and was probably used as a sacristy. The sacristy was a major obedientiary whose duties became so wide-ranging that, in the larger houses of the later Middle Ages, he had many assistants who could include not only the usual sub-sacrist but a master of works, treasurer, revestarius and assistant sacristan. His responsibilities could range from collecting salt from the kitchen for the consecration of holy water to the care of the cemetery. Essentially the sacrist was responsible for the church, its furniture, fittings and supplies: 'Let the sacrist, then if he love the Lord, love the church. The more spiritual should he be, both day and night, to make the church useful and seemly in every way' (Barnwell Observances).

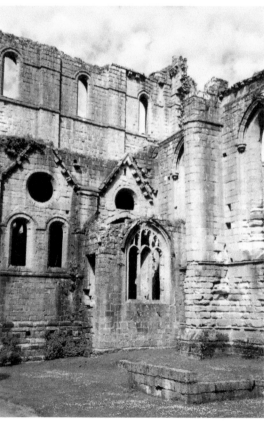

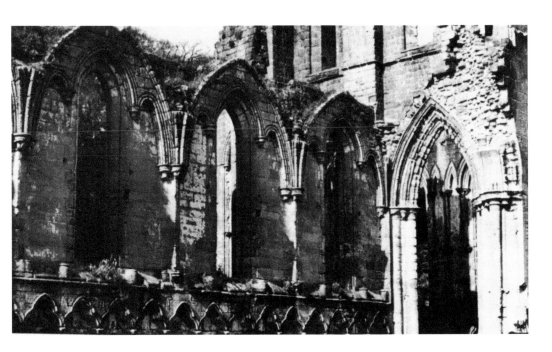

Presbytery Extensions, Fountains Abbey

The extended presbytery dates from 1210–20. In three of the five bays, the work is largely by Abbot John of Ely (1211–19), but it was finished by John of Kent. This arcade comprised of a series of trefoil heads supported on detached shafts of Nidderdale 'marble'. The arcading was set above a wall bench and mirrored a free-standing arcade within the main area. John of York must have been working on this on his death in 1211, for abbey documents record he had only completed a few of the piers.

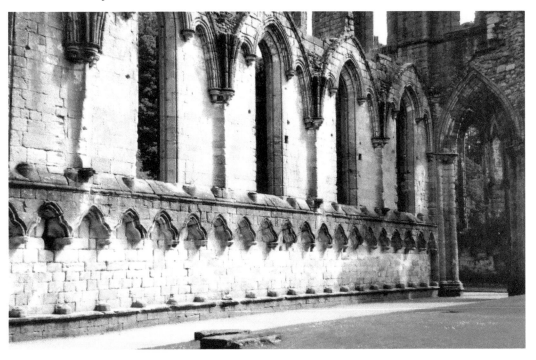

Undercroft Interior, Fountains Abbey

Above, the undercroft interior, showing alternate small and large windows in the dormitory; low down to the right is a blocked window of the earlier dormitory (pre-1146 fire), and left is a blocked archway used in the late twelfth-century rebuilding. While below is a surviving part of Abbot Henry Murdac's east cloister range. Among the many smaller rooms was a prison to confine both clerical and secular criminals, for it should be remembered that abbots also had jurisdiction to try persons and even pass sentence of death.

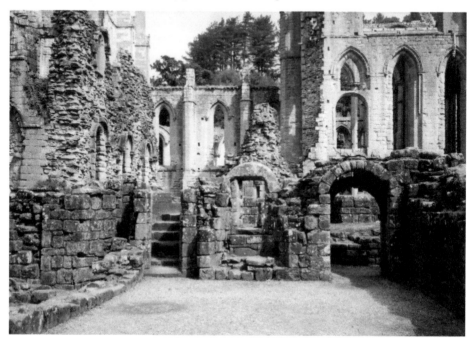

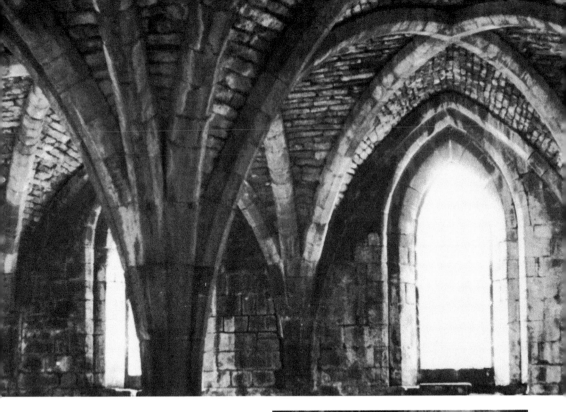

Lay Brothers' Refectory, Fountains Abbey

Rib vaulting in the lay brothers' refectory (south end of the lay brothers' range) dating from 1180 to 1200. Note the absence of capitals where the ribs spring direct from the columns. Below, similar ribbing to be seen in the warming house with its great fire seen to the left. Fires were permitted here between 1 November and Good Friday and monks could come and warm themselves after working outdoors. Above this chamber was the muniments room where all the abbey's documents were kept dry by the rising heat going up the chimney.

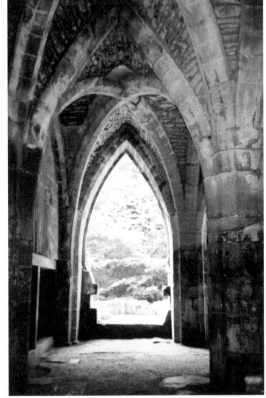

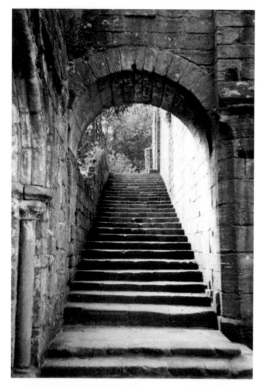

The Destruction of Fountains

In 1140 a dispute began over the election of a new Archbishop of York, between two candidates, Abbot Henry and Abbot William, supported by King Stephen and opposed by both the Augustinian and Cistercian Orders. The monks took the matter to Rome and persuaded Pope Eugenius III, himself a Cistercian monk, to back the monks against the king. So intense was the antagonism in 1146 that supporters of Archbishop William marched on Fountains seeking to murder Abbot Henry. Unable to find him, they sacked the abbey and fired its buildings. Serlo, who was present during the attack, tells how 'the convent stood by and saw the buildings erected by the sweat of their brows enveloped in flames and soon to be ashes, and that only the oratory and offices adjoining it reserved for prayer remained half-consumed, like a branch plucked from the burning'. This was a slight exaggeration to judge from what survives, but excavations have proved that his overall description of the event was reasonably accurate. Traces of a serious fire have been found, sufficient to melt window glass and bring down wall-plaster.

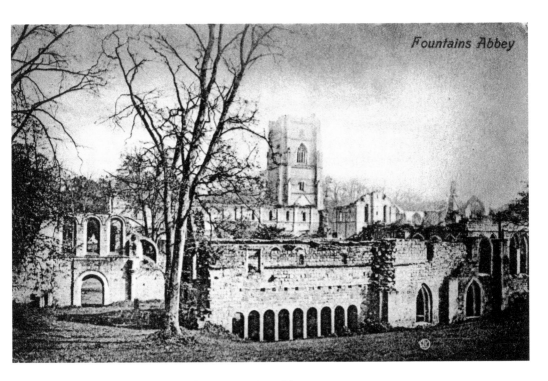

Toward the Lay Brothers' Toilets, Fountains Abbey

This early view *c.* 1900 of the abbey ruins shows the arcade of the lay brothers' toilets, which are built over the waters of the Skell, so that waste fell directly into the fast-flowing stream and was carried away. The toilets were accessible on two levels; from here on the ground floor, or from the end of the lay brothers' dormitory on the upper floor. The river served as the abbey's drainage system and fresh drinking water came from numerous natural pure springs on the hillsides.

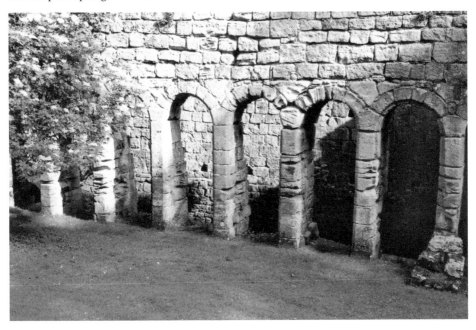

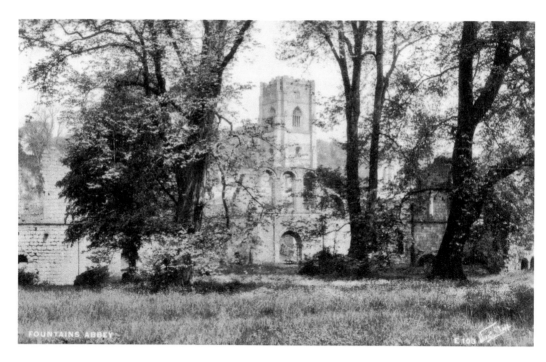

Looking North, Fountains Abbey

The bottom picture shows the bridge over the Skell leading to the guesthouses and the lay brothers' reredorter (page 67). This accommodation was provided by Abbot John of Pipewell. The new work can be identified by the use of gothic lancet windows to light the lay brothers' refectory on the ground floor, though the windows of the dormitory above continued the original design. It was at this point that the ground-floor rooms were vaulted. Both the walls and vault retain extensive traces of the 1170s paint scheme.

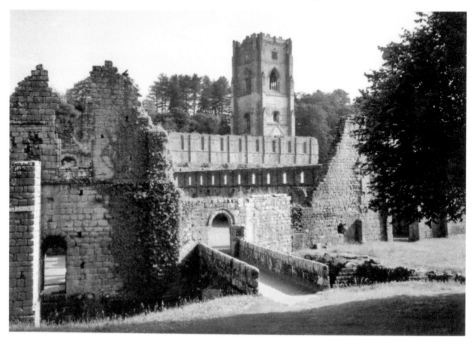

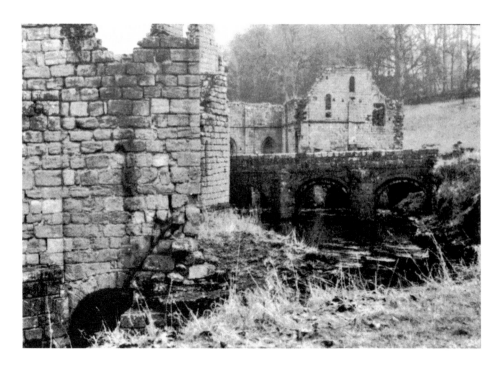

Guest House Toward Lay Brothers' Reredorter
The corner of one of the guest houses and the twelfth-century bridge can be seen as the observer looks toward the end of the lay brothers' reredorter. The reredorter was the communal toilet block at the end of the dorter, which was the communal sleeping dormitory of the monks, or in this case, the lay brothers. The monks had their own dormitory or dorter and reredorter. Originally, the dorter was a long open hall, but over time, in the interests of privacy, it became divided into separate sleeping cubicles.

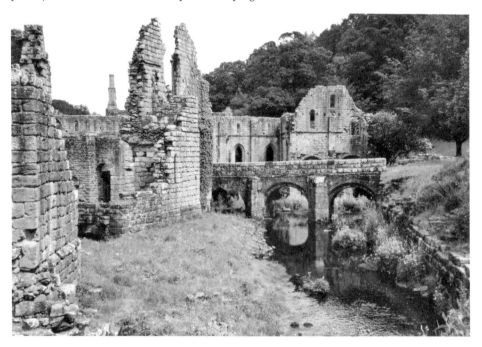

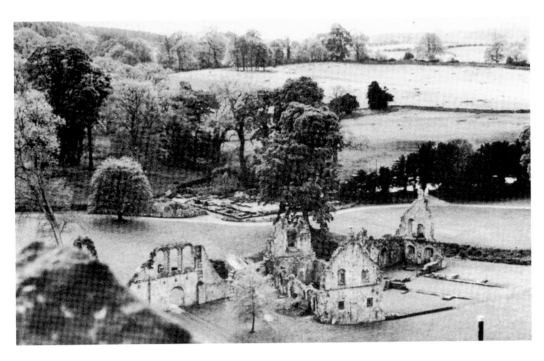

East and West Guesthouses

Built in the 1160s for important visitors, they remain largely as they were first built and are among the best surviving examples of twelfth-century domestic architecture in England. To their east (left) is the gable wall of Abbot Pipewell's lay brothers' infirmary. In 1849, Richard Walbran began excavations here; the masonry he recovered was carefully stacked until 1988. It was while digging that he found that 'the last supply of coal that the house had needed remained under the sward'.

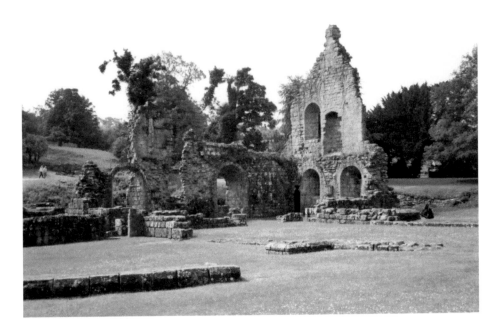

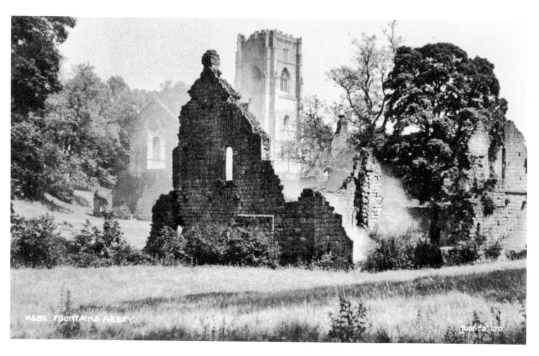

The Guest House Ruins, Fountains Abbey

Guests and travellers were welcome at the abbey, though women of whatever rank would have to stay in the Outer Court or beyond. In 1160, Abbot Richard built two fine, two-storey guesthouses for important visitors. Each floor had a hall with a fireplace, a bedchamber and a toilet over the river. From abbey accounts, minstrels, travelling players, a fool, and even a 'strange fabulist' (a magician?) were paid to entertain the visitors at various times.

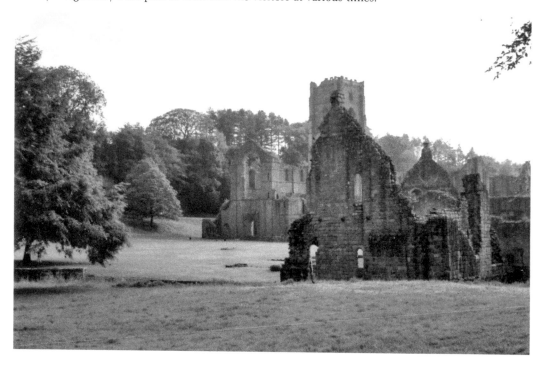

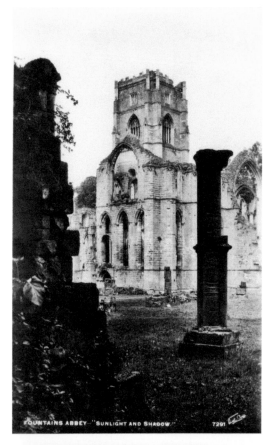

FOUNTAINS ABBEY—"SUNLIGHT AND SHADOW." 7291

The Infirmary, Fountains Abbey

Abbot John Darnton provided this later infirmary range with a meat refectory, replacing an earlier building. Little now remains of this second infirmary, but when it was excavated in the 1850s it was found to resemble a domestic hall with a raised dais at its west end and a service passage at its east end. The dais and floor were tiled. Among the material found was a pewter plate marked with a single horseshoe to demonstrate that it was the property of the abbey. The pillars were reconstructed at that date.

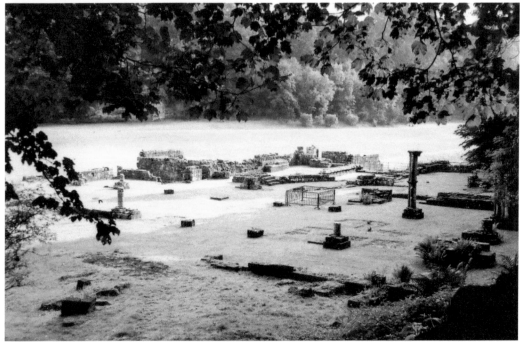

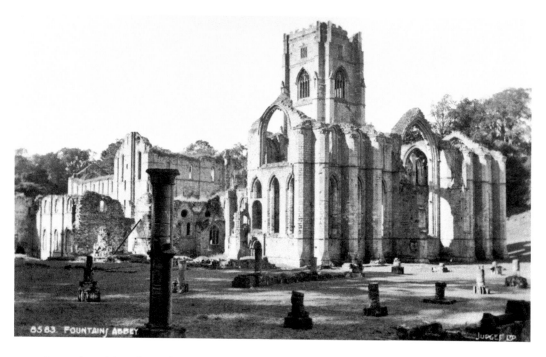

Fountains Abbey from the South-East

A Judges postcard from around 1900, showing the abbey from the south-east with the ruins of the infirmary. Thomas Walbran, the archaeologist from Ripon, reset these two piers in the infirmary, which he had found in a fallen state during excavations in the mid-nineteenth century. Below, almost the identical scene on a Valentine's postcard can be seen. Many of these rooms on the ground floor are presumed to have separate fireplaces to warm the old, infirm and sick who occupied them.

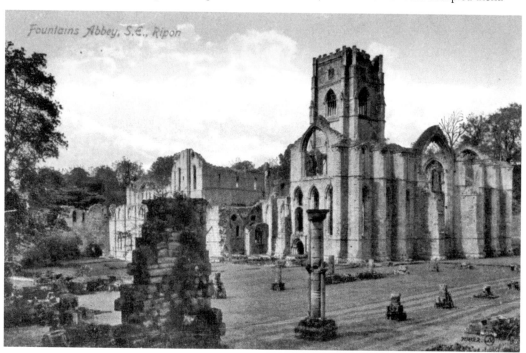

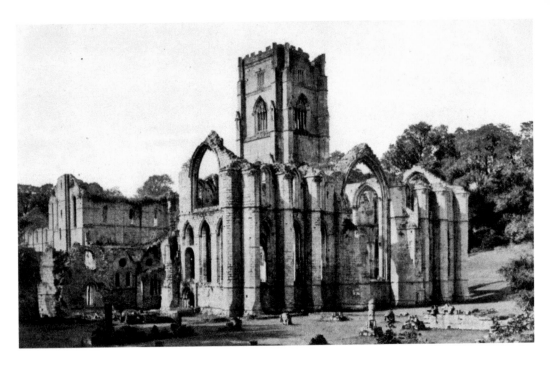

East End, Fountains Abbey

A Photochrom view of Fountains Abbey from the south-east and below a similar view by the postcard company Hartmann on an early postcard dated pre-1902. In both scenes it is possible to see the south transept sacristy mentioned on page 62. The message on the back from Doris to her dad while on holiday cryptically says, 'the misses [landlady?] says she was sorry you had to go away just when the fine weather came ...she is very kind but I don't like him ...'

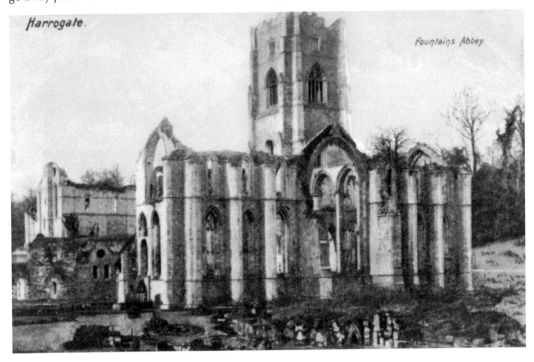

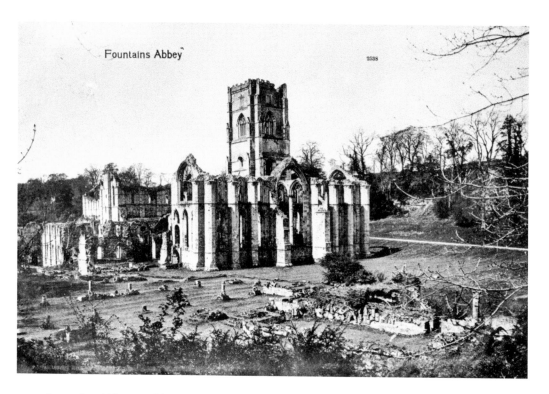

Fountains Abbey

Fountains Abbey Looking West

A Valentines XL series postcard looking towards the west and showing the east end, while below the rather well-attired lady artist in a summer bonnet is painting the same view on this postcard by Tennyson & Company, Art Publishers of Leeds. As this scene was the focal point of Aislabie's planned garden scheme it is no wonder that it became a subject of many postcard publishers and probably there are more cards with this view than any other of Fountains.

Fountains Abbey

Aspects of Fountains Abbey

Above, the repair of the parapet of Huby's tower during the 1930s without the aid of scaffolding. The corner of Huby's tower that they are working on can be seen in the postcard view below, top right, where there is a distinctively shaped portion missing. This interesting if somewhat idealised view is on a postcard advertising Colman's mustard products and is dated by postmark to 1903. The sender was writing to a coal merchant asking for a delivery of 'nutty slack' – you just couldn't make it up.

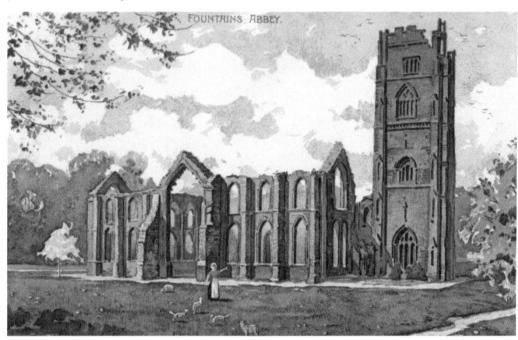

FOUNTAINS ABBEY.

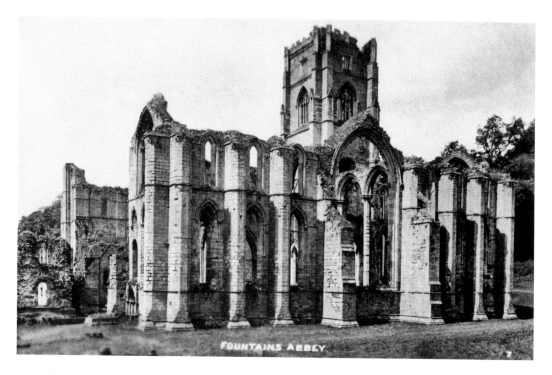

The East End and Window, Fountains Abbey

The recent history of Fountains is basically one of repair and presentation to an increasing number of visitors. The site had been regularly open to paying visitors since the mid-nineteenth century, but it remained in a dangerous condition. By the late 1920s, the ruins were in a worrying state, and though privately owned, the Office of Works was sufficiently concerned to undertake a study of the site and make recommendations to the estate regarding the necessary repairs. The estate, grant-aided by the Office of Works, began a campaign of repairs.

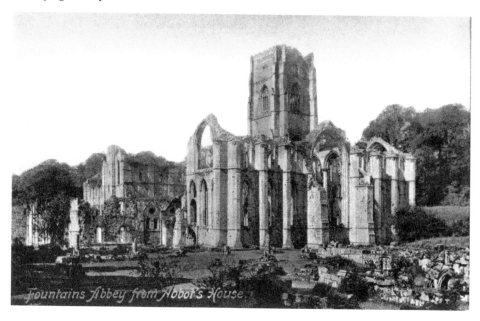

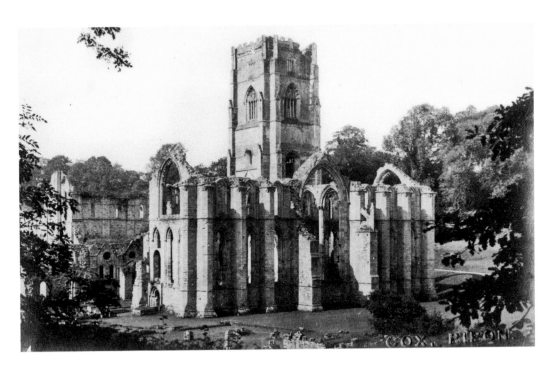

Fountains Abbey from the Abbots' House

In 1966, the estate was sold to the West Riding County Council who placed the abbey ruins in the guardianship of the Ministry of Public Buildings and Works. Ownership passed to North Yorkshire County Council after local government reorganisation in 1974, and North Yorkshire in turn sold the Studley Royal estate to the National Trust in 1983. Today, the ruins are conserved by English Heritage, the lineal successor of the old Office of Works. Being in the guardianship of the state, the abbey ruins have an assured future.

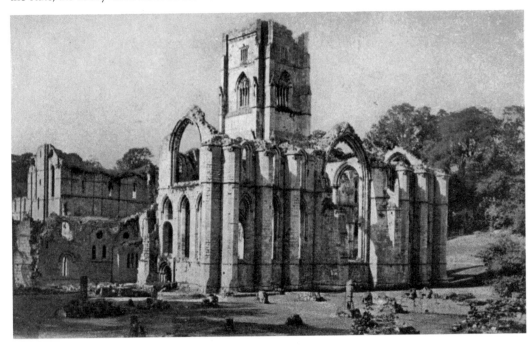

Fountains Abbey.

"I have four good reasons for total abstinence— my head is clearer, my health is better, my heart is lighter, and my purse is heavier."

Dr. Guthrie.

Join the Sons of Temperance Friendly Society. Membership open to Men, Women, and Children.

Issued by THE ORDER OF THE SONS OF TEMPERANCE FRIENDLY SOCIETY—Membership, 300,000. Funds, £675,000.

Sons of the Temperance Society

A singularly interesting postcard and one of a series promoting the Sons of the Temperance Society, one of many religious societies established in the nineteenth century to combat the 'evils of drink'. Such groups also acted as a form of welfare group, hence the importance of funds, which could be drawn upon by members in times of hardship. The funds were partly built up from member's subscriptions and partly from philanthropic donations from wealthy middle-class persons who felt it was their duty to help the less well-off.

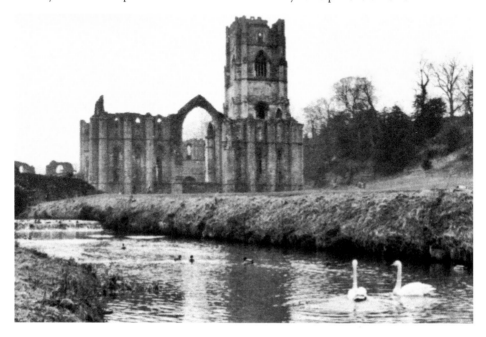

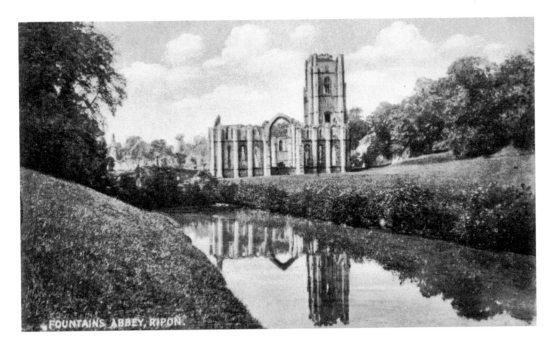

FOUNTAINS ABBEY, RIPON.

River Skell and Fountains Abbey

William Aislabie (1699–1781) inherited the Studley Royal estate in 1742 and began a grand scheme of joining the family lands with the Fountains Estate which he acquired in 1767 and landscaping the entire property as one huge estate and park. He began to clear rubble from Fountains Abbey to make a route for visitors; the abbey ruins were to be the focal point. He also straightened the River Skell below the abbey and inserted two cascades, transforming the stony river into a seemingly unbroken sheet of water.

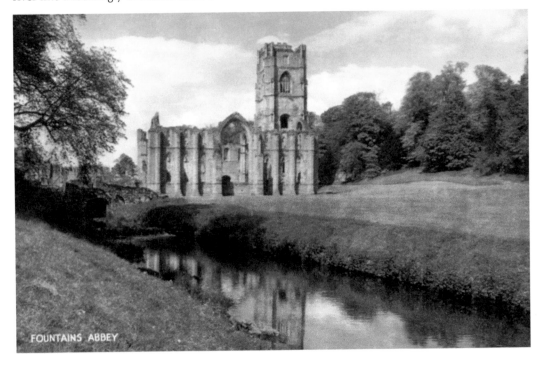

FOUNTAINS ABBEY

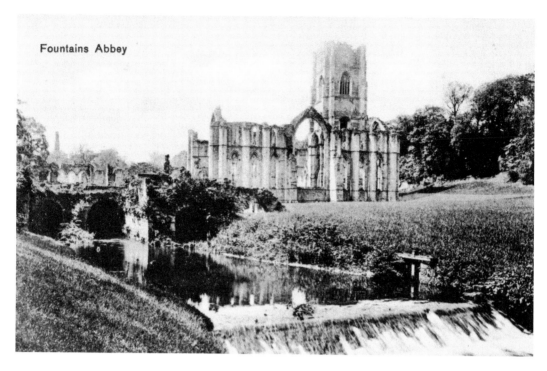

Fountains Abbey

The Upper Weir, River Skell, Fountains Abbey

At source, the River Skell is not a notable water course; it is shallow and stony, prone to drying up in hot summers. The insertion of two cascades or weirs into the flow of the River Skell had the effect of causing a dam, which increased the volume of water by impeding its flow and enabling a good head of water to be obtained all year round. This also made it more suitable for landscaping purposes.

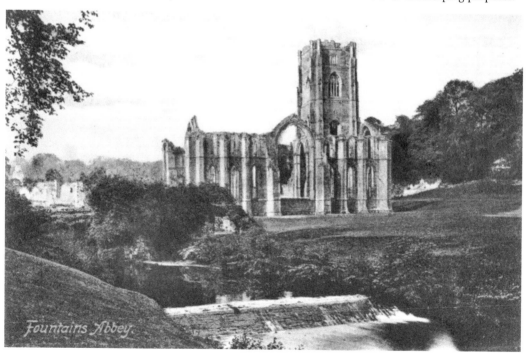

Fountains Abbey

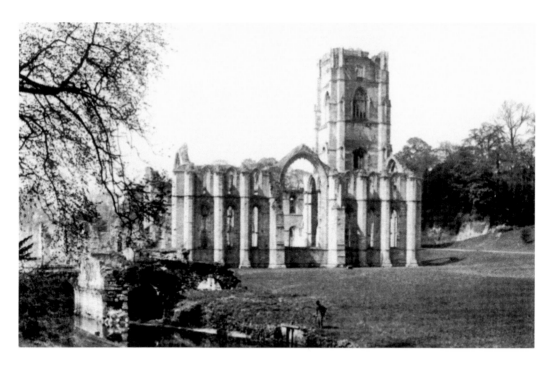

Fountains Abbey from the South-East

To appreciate the water features of Studley Royal leading up to the focal point of the ruins of Fountains Abbey, it is best approached at the bottom end by the lakeside entrance. The estate came to him on his marriage to Mary Mallorie, heiress of the Studley estate. The significance of the eighteenth-century water garden was recognised in 1986, when it became only the twelfth World Heritage Site in the United Kingdom. Top, a very early Francis Frith postcard c. 1895 showing the east window almost as it exists today.

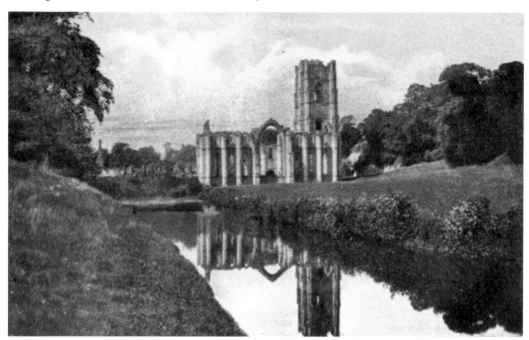

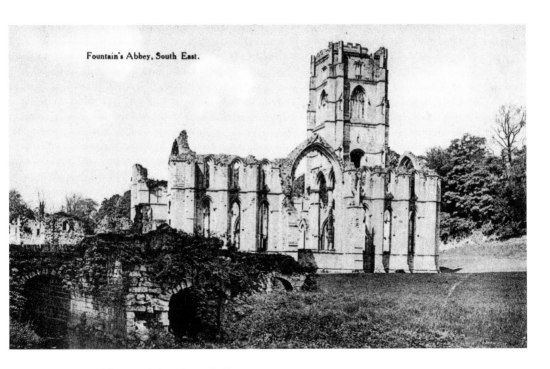

Fountain's Abbey, South East.

Fountains Abbey and the River Skell

'In the wildest part of the park between high hills is a fine canal with a waterfall of ten feet and another now making, as also sinking twelve acres of ground five feet lower in order to drownd it and so make a terrace twelve feet wide round it.' This is how one visitor, Mr Knatchbull described the work in 1724, then in progress. The two figures in the postcard below are the same professional models as seen previously.

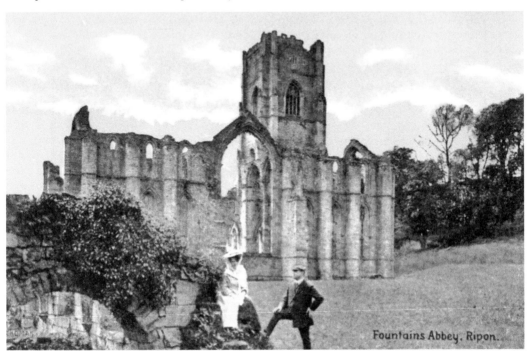

Fountains Abbey. Ripon.

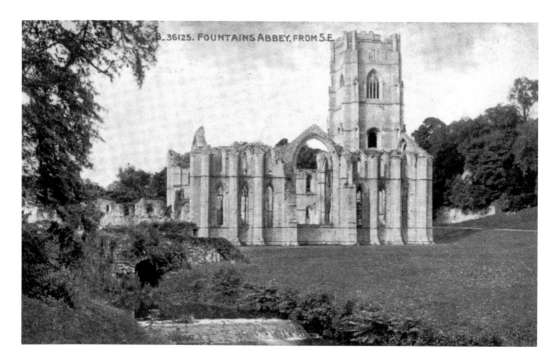

The Upper Weir, River Skell

By building a dam at the outflow he created a lake three times the size of the original. The small buildings by the Cascade, the Fishing Tabernacles, were added in 1728, perhaps to distract attention from the two huge culverts, or tunnels, below. Opened by the sluice gates on the canal sides, these are used to reduce the effects of flooding in the valley during the winter and spring months and to drain the canal for repair.

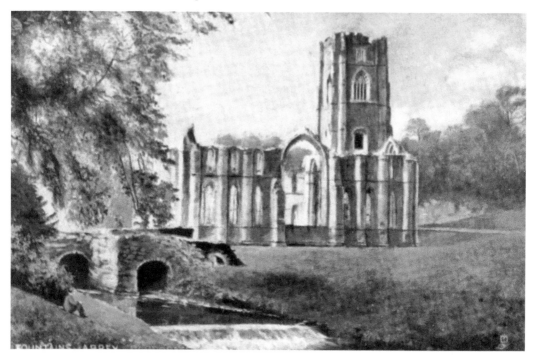

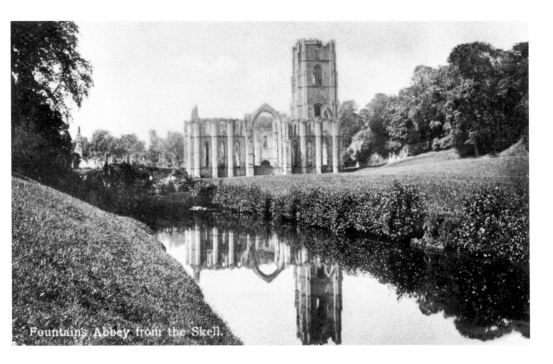

Fountains Abbey from the Skell.

Fountains Abbey from the Skell

Another common view of Fountains Abbey showing the East End from the River Skell. The bottom card is part of an extensive series of postcards showing famous places across the United Kingdom, and was issued by the Great Northern Railway Company (GNR), printed on their behalf by the Photochrom publishers. While to serious postcard collectors, common views of common subjects are often scorned, there is nevertheless a worthwhile goal and over time it is possible to trace changes.

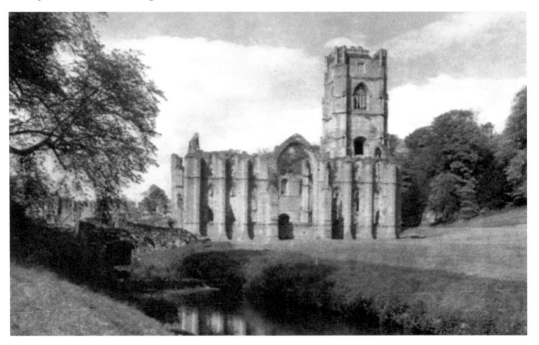

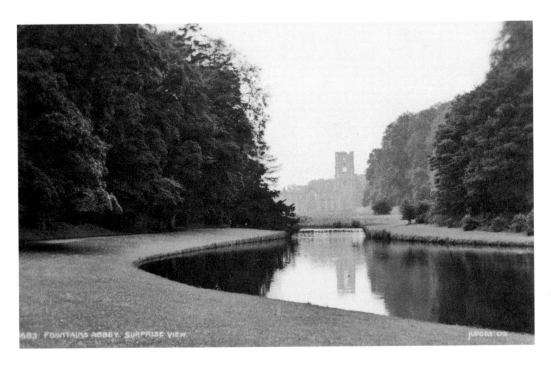

Surprise View, Fountains Abbey

The transformation of the River Skell into a vision of unbroken water is best appreciated from the 'Surprise View', one of the best-loved of the abbey vistas. The raised path of 'High Walk' to the north of the river, was perhaps in order to have a dry perambulation above the marshy valley bottom during the winter months when the Skell might overflow and flood. I most enjoyed the view early on a summer's morning when the light seems to have a mystical quality, as in this Judges postcard.

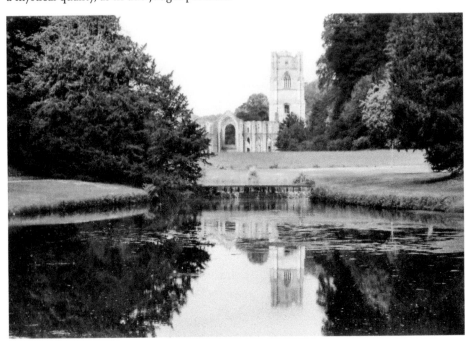

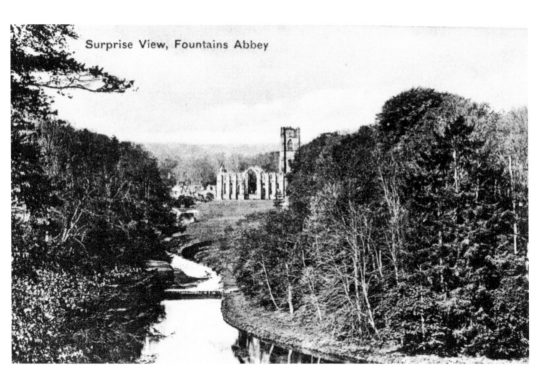

Surprise View, Fountains Abbey

Surprise View from Anne Boleyn's Seat

The 'Surprise View', best appreciated from 'Anne Boleyn's Seat' on a higher level has been captured by artists and photographers from as early as 1758. That year the artist A. Walker painted the scene after the style of Balthazar Nebot, which later appeared in engravings, the most celebrated of which is the one by Storer in 1830. Why the vantage point is known as Anne Boleyn's Seat is unknown – certainly she never visited here.

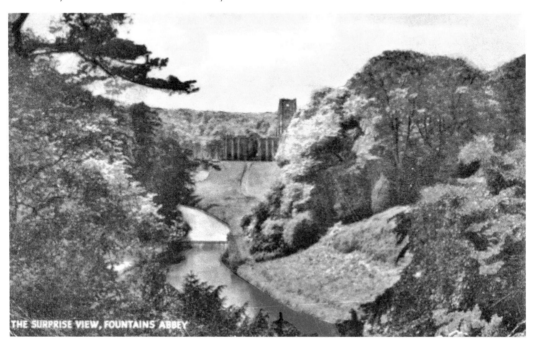

THE SURPRISE VIEW, FOUNTAINS ABBEY

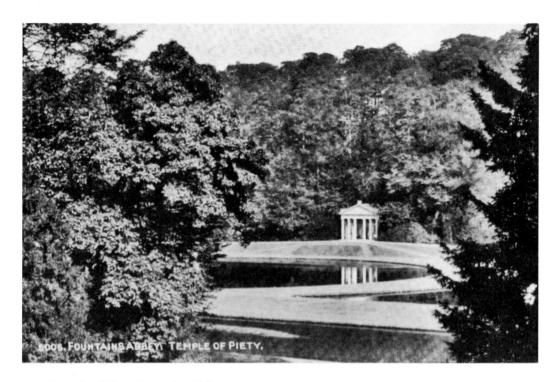

soos, FOUNTAINS ABBEY. TEMPLE OF PIETY.

Temple of Piety, Fountains Abbey

First named the Temple of Neptune after the statue of Neptune in the centre of the Moon Pond, it was renamed the Temple of Piety. Inside is a fine plaster roundel by Guiseppe Cortese, which depicts the 'Grecian Daughter' feeding her father. In 1768, it is recorded that it was set up with 'six chairs, a tea table and a little stand', which suggests that visitors were entertained here. The steep banks to the right of the path have been replanted with species of the Aislabie's original scheme.

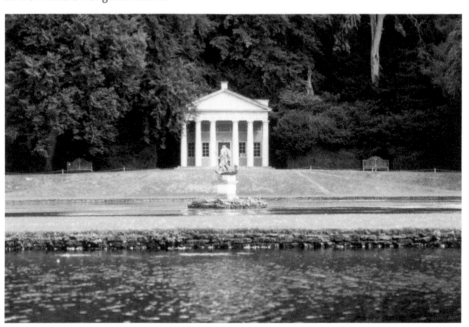

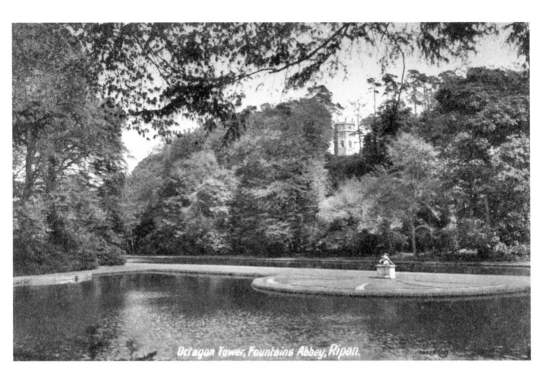

Octagonal Tower from the Water Gardens
The two serene ponds named the Moon and Crescent, with their geometrical layout and statutes, make up the most formal aspect of the gardens, which owe their origins to the formal gardens of France in the early 1700s that found favour with wealthy English travellers. However, the fashion began to decline and Aislabie artfully blended the two fashions by this elegant water garden in a contrived 'natural' setting.

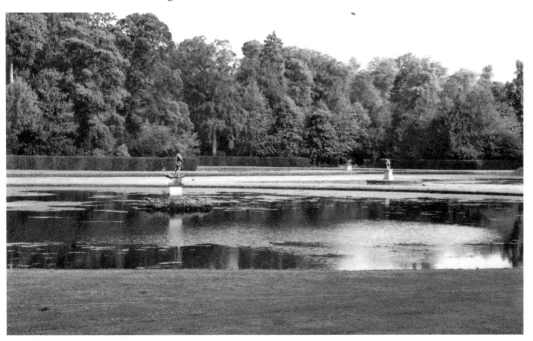

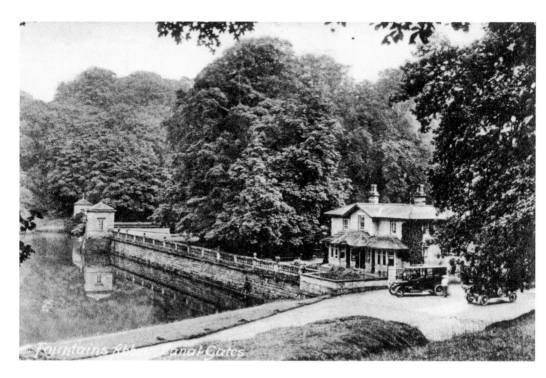

The Canal Gates and Lakeside, Fountains Abbey

The building, which stands here at the lower end of the canal near the Canal Gates where there is an entrance to Fountains Abbey, dates back to the 1860s. Known as the Studley Tea Rooms, it was probably built as a house for the estate stewards of the 1st Marquis of Ripon. The groundsman's wife first served tea here to visitors in the 1890s, beginning a long tradition of hospitality at Fountains, which could be said to have stretched back to the days of the monks themselves!

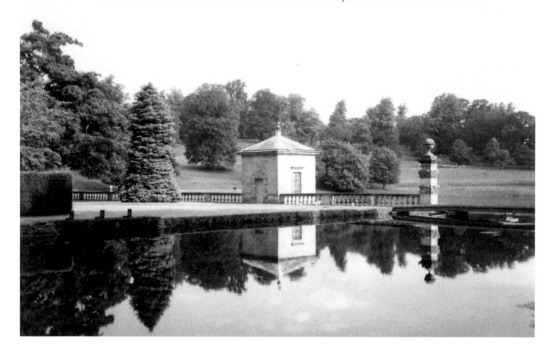

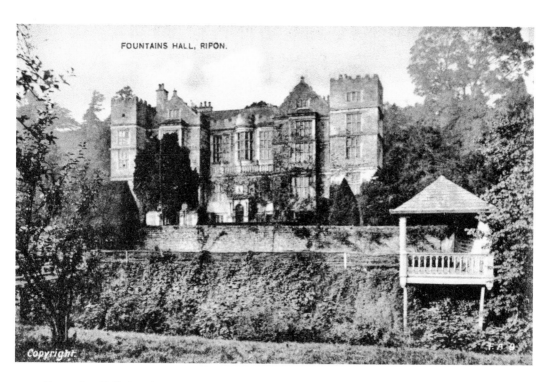

Copyright.

Fountains Hall, South Front

Fountains Abbey came into secular ownership following the Dissolution of the Monasteries in 1539. For a few months afterwards, the abbey buildings stood empty in the hope that it would be chosen as the site for a new Dales bishopric. This was not to be, and shortly after 1540 the buildings and part of the estate was sold to Sir Richard Gresham, whose family sold them on to Stephen Proctor who built Fountains Hall. After passing through several hands, the Messenger family in 1787 sold it to William Aislabie for £18,000.

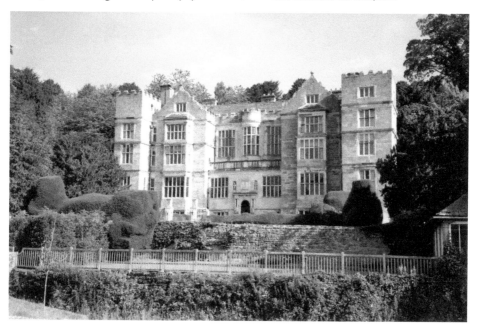

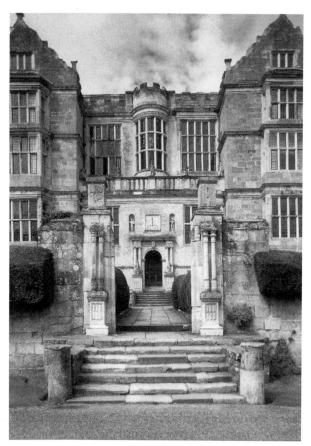

Fountains Hall, Main Entrance
The front façade, with
its impressive windows
and seventeenth-century
ornamentation, is in the style
of Robert Smythson, architect
of Hardwick Hall in Derbyshire,
but it is not known who Proctor
engaged as architect here. The
front steps lead up to a lower hall
with a minstrels' gallery. Above is
the Great Chamber containing a
magnificent stone fireplace and
the oriel window. The entrance is
flanked by classical columns and
martial figures. Interestingly, while
appearing to look symmetrical, the
two sides are far from it.

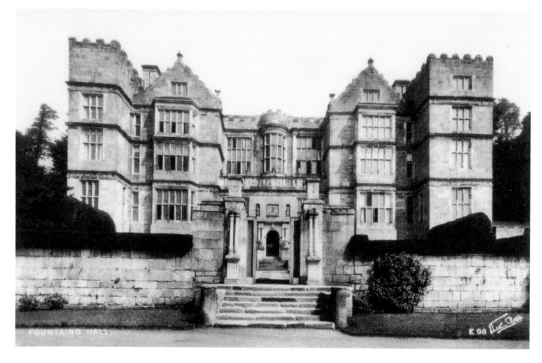

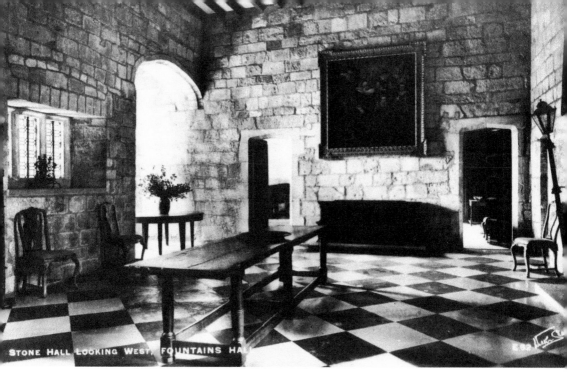

Fountains Hall, Stone Hall Looking West

Sir Stephen Proctor bought the Fountains Abbey estate and adjoining land after a period when it had lain neglected for almost sixty years. He began the construction of Fountains Hall in 1598 using stone from the ruins of the abbey, and by 1604 he was living therein. Changes over the centuries have made it difficult to guess at the original layout of the hall. Doors, windows, panelling, even a staircase have all been moved at one time or another. This is the lower chamber the visitor first enters.

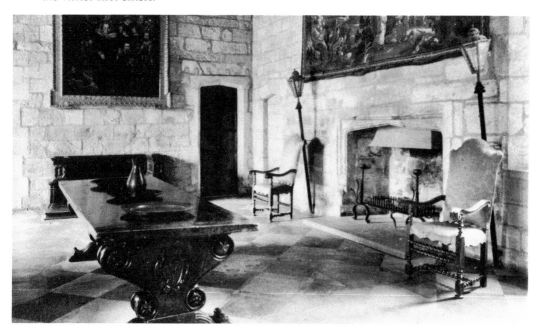

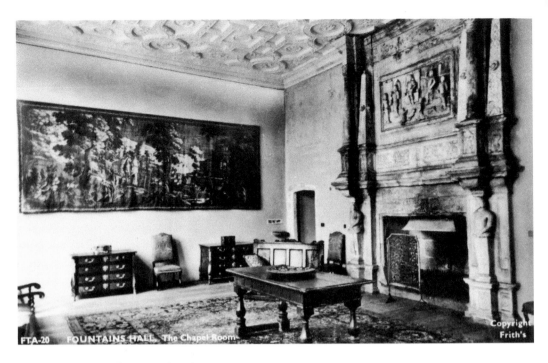

FTA-20 FOUNTAINS HALL. The Chapel Room

Copyright Frith's

Fountains Hall, Great Chamber

The front steps led up into the lower hall or Stone Hall and then another flight led to the Great Chamber, now known as the Chapel Room. This chamber is dominated by a magnificent carved stone fireplace with the panel showing 'The judgement of Solomon' and, of course, the oriel window with its array of fine heraldic glass with the coat of arms of Sir Stephen Proctor taking pride of place.

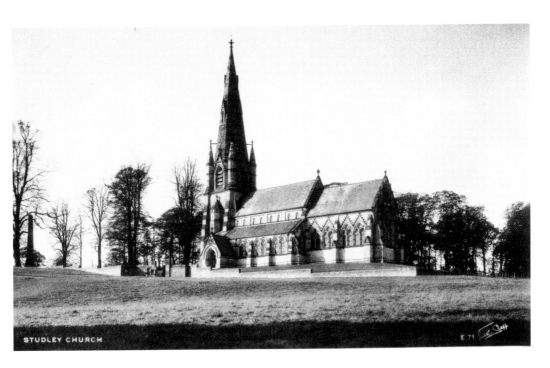

STUDLEY CHURCH

E 71

Church of St Mary, Studley Park, Fountains

The 1st Marquis of Ripon, owner of Fountains estate from 1845 to 1909, commissioned the eminent Victorian architect William Burgess (1827–81) to build a church for the use of the family and estate workers, which was erected in 1870. Burgess was inspired by medieval Gothic buildings, which is reflected in the design and decoration of this magnificent Grade I listed building. Inside, the sanctuary is rich in gold and colour. The bronze door and the Virgin and Child sculpture were personal gifts from Burgess.

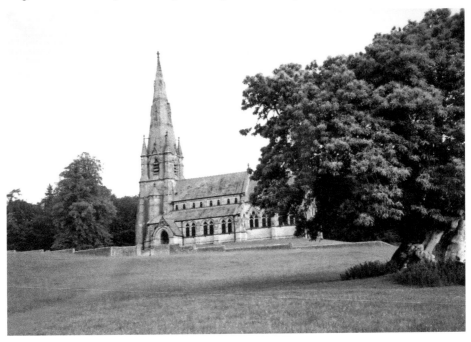

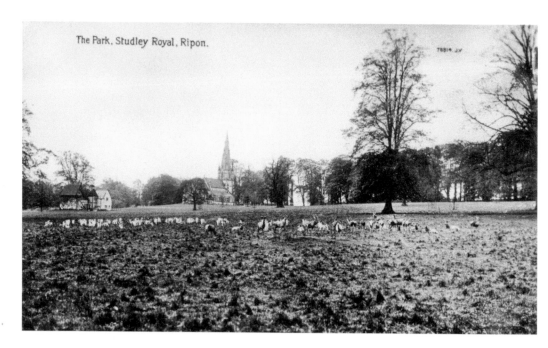

The Park, Studley Royal, Ripon.

Views Across the Deer Park, Studley Park

The landscape of the Deer Park holds evidence of human occupation since prehistoric times. There are old roads and paths, 'ridge and furrow' cultivation marks and sites of medieval and later dwellings. Maps from the late 1500s show a fenced park, and a century later George Aislabie, John's father enclosed at least one side with a stone wall. In 1693, the park was established and held some 500 deer. The present obelisk of stone replaced an earlier wood one in the early 1800s.